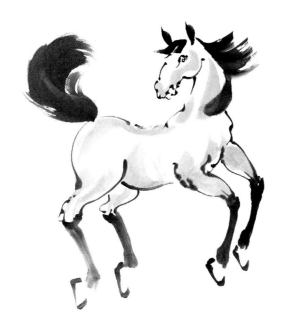

# CHINESE
# BRUSH PAINTING

### A complete course in traditional and modern techniques

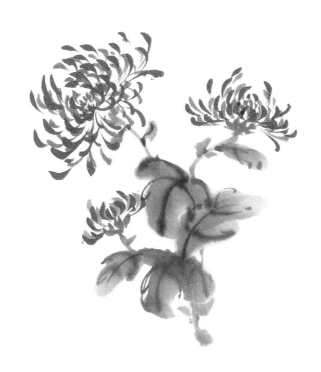

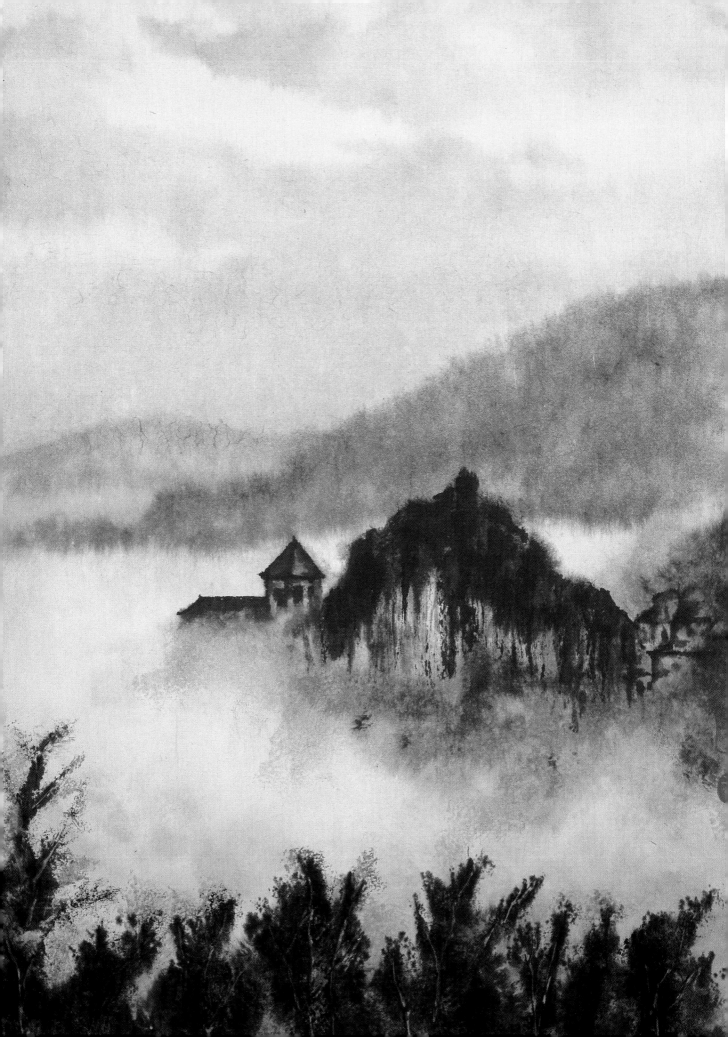

# CHINESE BRUSH PAINTING

## A complete course in traditional and modern techniques

JANE EVANS

COLLINS

First published in 1987 by
William Collins Sons & Co., Ltd,
London · Glasgow · Sydney
Auckland · Toronto · Johannesburg

Design: Lee Griffiths
Photography: Peter Lofts

**British Library Cataloguing in Publication Data**
Evans, Jane
  Chinese brush painting.
  1. Brushwork   2. Painting, Chinese
  I. Title
  751.42   ND1505

ISBN 0 00 412159 7

Set in Galliard
by V & M Graphics Ltd, Aylesbury, Bucks
Colour reproduction by Bright Arts, Hong Kong
Printed and bound in Hong Kong
by South China Printing Co.

# CONTENTS

## Acknowledgements

First of all I must thank my teacher, Professor Chen Bing Sun, for giving me such an excellent grounding in Chinese brush painting. I should also like to thank my own students, past and present, particularly Sheena Davis, for their interest and suggestions.

The following people very kindly lent paintings as examples for the book: Miss E. J. Bagguley, Dr & Mrs A. Butterworth, Dr & Mrs C. Cherry, Mr & Mrs C. Cole, Mr & Mrs R. E. Davis, and Mrs P. Hammersley.

The discussions of history, philosophy and aesthetics owe most to three sources: Kwo Da-Wei's excellent *Chinese Brushwork* (Allanheld & Schram/George Prior, 1981); Witold Rodzinski's very readable book *The Walled Kingdom* (Fontana, 1984); and a stimulating series of lectures given by Professor Michael Sullivan at Cambridge University.

Many thanks are also due to the people at Collins who worked on the book: to Cathy Gosling, Lee Griffiths, and especially Caroline Churton.

Finally, I must thank my family for their support. Thanks are particularly due to my husband for his continual help – without his persistent encouragement the book would never have been begun, let alone completed.

## Note on the spelling of Chinese words and names

The Chinese have recently adopted a new style of Western transcription known as pinyin. This has largely replaced the Wade-Giles system more familiar in Britain.

With most of the Chinese words and phrases in this book I have tried to use the new spelling, if only because it gives a much clearer idea of how words are pronounced. With names, however, I have used a mixture. There seems no point in rendering the familiar in an unfamiliar form. How many people, for example, recognize Peking in its pinyin manifestation of Beijing? Similarly, with some well-known artists who are frequently mentioned in the literature on Chinese art, I have stuck to the more recognizable form. In the case of recent artists, however, I have tried to use the spelling that most often appears in print, both because it is more familiar and because with living artists especially it seems likely that they have so chosen to style themselves.

# PREFACE

This book introduces the aspiring artist (amateur or professional) in the West to the substantial possibilities for innovation in expression offered by a mastery of Chinese brush painting techniques and attitudes.

It is intended as a comprehensive 'how to do it' guide for would-be brush painters and aims to take them step by step through the subject.

The author has been teaching Chinese brush painting for eight years and has realized the need for such a manual both as a supplement for those lucky enough to have access to classes and as a complete course for those working by themselves. Nearly everyone who starts Chinese brush painting wants to go on with it. This is partly due to the extraordinary artistic versatility of the medium but it must also be partly because Chinese brush painting seems to exert a calming influence on its practitioners, putting them at peace with the world. It appears to have an effect somewhat similar to that of meditation.

The book aims to give students a sense of progress, there being a clear and time-honoured sequence in the skills to be mastered, and definite landmarks of achievement such as are manifested in a graceful plum blossom or spirited bamboo which can be executed after only a short time. Ends in themselves, these landmarks contribute to an ever increasing and deepening knowledge of the subjects and repertoire of skills.

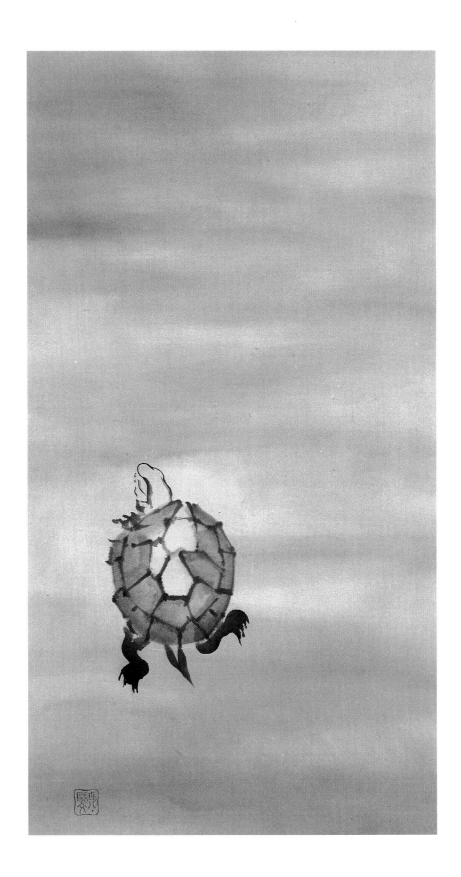

# THE APPEAL OF CHINESE BRUSH PAINTING

In the West we tend to expect painters to be flamboyant, excitable, untidy and often amoral! The Chinese painter, by contrast, is contemplative and serene, steeped in the philosophical and ethical preoccupations of his society. Perhaps this is because Chinese brush painting provides its practitioners with more than just technical skills. To learn brush painting, the would-be artist should strive not only to master the techniques but also to understand something of the philosophy and aesthetics involved. Its appeal is partly like that of other Eastern imports such as yoga and kung fu, for it seems to provide a soothing influence brought about by mastering a traditional skill through a time-honoured, ritualized learning process. Japanese Sumi, or brush and ink, painting has been described as a 'meditation in ink'[1] and this is equally applicable to Chinese painting. It scores over meditation, however, in that it can convey its calming effect to the spectator as well as to the performer. The artist also has the satisfaction of following a well-marked path to deeper understanding, with clear stages of achievement along the way.

This is not to say that Chinese painting has little to offer in the technical line. Chinese painting materials are very versatile, far more so than their nearest Western equivalents. Chinese ink is capable of an endless variety of shades and depths of black and grey. The colour pigments combine the best properties of watercolour and those of tempera, having the translucency of the former and the fixity of the latter. The brushes, too, are almost infinitely adaptable. A good wolf-hair brush can hold considerably more paint or ink than its Western counterpart. This allows you to load it with up to three tones or colours at once so that, for example, you can complete a plant in one go without having to go back to your palette for more colour. This helps to achieve spontaneity and unity. Regardless of its size, a good brush will enable you to draw a fine line and, if spread appropriately, will give you a number of 'split-brush' and 'feather' strokes which a Western sable brush would resist. Horse-hair and goat-hair brushes create special effects of which no Western brush is capable. Chinese paper comes in several qualities, some more absorbent than others. Even the least absorbent feels like blotting paper to artists accustomed to watercolour paper, but once control of the absorbency is mastered, there is a multitude of effects to be achieved with the different kinds of paper.

Westerners are sometimes put off by the thought of the effort needed to master the disciplined technique demanded by Chinese painting. In fact, you will not find yourself becoming impatient because you will progress steadily from one subject to

1. *Sumie-e*, Paul Siudzinski, Sterling Publishing Co., Inc., New York, 1979.

Turtle. *The use of space and the gentle tones of the wash give this painting a peaceful atmosphere*

another. For example, you master plum blossom before you move on to bamboo, and you must master bamboo before you move on to orchids. Thus your progress is punctuated by the acquisition of specific skills and the production of pleasing pictures. Over a period of time you will find you have imperceptibly built up a store of technical knowledge that will enable you to tackle any subject. Far more than with any other painting technique, such as oil or watercolour, you will enjoy a sense of development and progress as you study. This feeling will never leave you, however long you brush paint.

The Western student brought up to believe in the importance of 'freedom of expression' sometimes worries that the emphasis on correct technique will lead to loss of artistic originality. This is felt particularly in the case of Chinese painting because it is traditionally learnt by carefully copying the works of established artists. Indeed, the problem has not gone unnoticed by the Chinese themselves: as long ago as the seventeenth century Chieh Tzu Yüan Hua Chuan in *The Mustard Seed Garden Manual of Painting* (1679-1701) stated, 'If you aim to dispense with method, learn method. If you aim at facility, work hard. If you aim for simplicity, master complexity.'[2] Just as a good driver does not think about changing gear, it is only when you have fully mastered the control of ink, brush and paper so that it has become almost subconscious, that you will be released from worry about your technical performance and be able to express yourself fully.

Even in the West it is only in recent years that method and technique have become suspect elements in the pursuit of good art: in the past painters studied hard under masters and copied their works assiduously. Today it is in fact mainly in the visual arts that we worry that originality may be smothered by technique. No-one suggests that ballet dancers should not learn the individual steps – it is how they are performed and put together that determines the merit of the performance. Brush strokes are the dance steps of painting and composition its choreography.

Learning by copying is especially useful for people not brought up in the East. Not only do Chinese art students have the advantage of having been taught to write using brush, ink, paper, and even many of the brush strokes, they have also been brought up with Chinese paintings and have absorbed a feeling for composition and colour in the same way that we in the West have become familiar with Leonardo, Renoir and Picasso. By copying from Chinese paintings, Western students can not only better appreciate the techniques and brush strokes used, but also begin to develop a feeling for composition and colour which will stand them in good stead when they produce their own 'original' works.

This does not mean that this method of learning has no drawbacks: indeed, the history of Chinese painting bears witness to these. There has been an inevitable tendency towards stylization and loss of freshness, and it is fair to say that in the past there have been fewer innovative painters in China than in the West. However, this is no longer the case. One of the beneficial effects of the impact of Western ideas and attitudes and of social and political upheaval has been a great burst of originality and innovativeness in Chinese painting.

Innovation does require effort, however. Provided you are aware of this and use the painted model as a general guide to brush strokes, colour and composition, rather than as a copybook to be slavishly imitated, the danger of simply learning how to copy rather than to create is not too great. Moreover, it can be totally overcome by your striving to become more observant of the things around you. Even though it is not used as a direct model, in the sense that Chinese artists do not traditionally sit in front of the objects they paint, you should be particularly aware of your environment. Watch birds: see how they are structured; how they land and take off; how they sit and stand; how they fluff up their feathers in winter. You should notice flowers, leaves, trees and rocks; observe colours and shapes; and discover how things work.

2. Facsimile of the 1887–8 Shanghai edition, translated and edited by Mai-Mai Sze, Princeton University Press, 1977.

There are plenty of precedents for Westerners in Chinese painting. In the seventeenth century several Jesuit priests went to China to convert the people to Catholicism. Some of them stayed to become court painters. The best known of these was Giuseppe Castiglione, court painter to Emperor Chien Lung. His Chinese name was Lang Shih Ning. Later, the Irish painter Chinnery was very influenced by Chinese painting and by his stay in China, and Van Gogh did a series of paintings trying to imitate the Japanese style. In the twentieth century several Chinese painters have started to look towards the West and a number of the more innovative ones have

View from Diani Beach. *This picture was entirely created with Chinese brush painting techniques and materials. The spaciousness in the composition is also Chinese. Nevertheless, the overall effect is Western because of the perspective and the texturing of the sky and sea*

studied abroad and adopted Western ideas on perspective and light.

The Western student will, however, never become Chinese, and should not try to. Hopefully you will achieve a blend of East and West. You will learn an idiom and a technique and come to grips with a philosophy and outlook. My own teacher, Chen Bing Sun, liked to have an occasional European in his class. He believed that the union of China and Europe produced something very interesting from the point of view of painting. Therefore, while it is of course very important that you should absorb the principles of Chinese aesthetics as you learn to paint in the Chinese style, do not forget that you are a Westerner. I hope by the end of this book you will have learnt enough to feel free to 'do your own thing'. In other words, keep using your own aesthetic judgement and compositional skills, and combine them with your new techniques. Remember that the word Chi-

nese in 'Chinese brush painting' refers to the brush, not to the artist.

As a final observation to help the Western student who is interested in taking up Chinese brush painting, it is perhaps worth remarking that Chinese painting lacks the self-conscious earnestness that frequently mars Western art. One of the most refreshing elements of Eastern art is its abundance of humour, as the painting below illustrates. This is not to say that Chinese painters do not take their work seriously, but they retain their ability to look at the world with a certain detached irony.

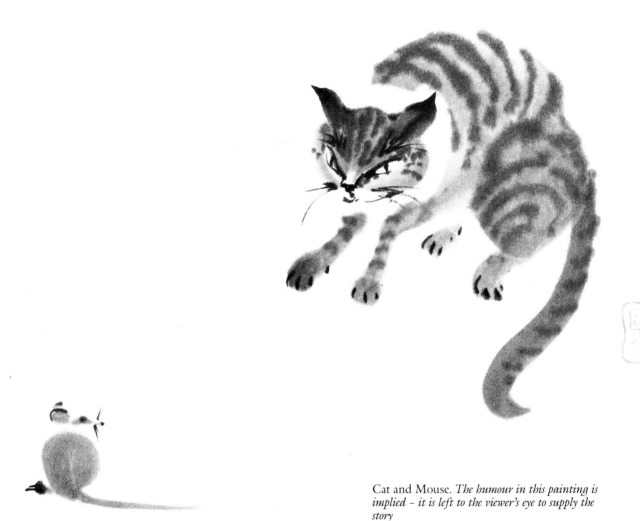

Cat and Mouse. *The humour in this painting is implied – it is left to the viewer's eye to supply the story*

# PAINTING IN CHINESE CULTURE

It is important to be able to put what you are learning into its appropriate cultural perspective. If you know, for example, a little about the philosophical foundations of Chinese painting you will find it easier to appreciate what qualities you should strive for and why. This book is intended to provide a practical course of instruction for the would-be brush painter: it is not an account of the history and philosophy of Chinese painting. However, this chapter attempts to sketch in some essential background while making no pretence at being a definitive guide. There are many excellent books available on these topics and the bibliography at the end of this book contains details of a few of them.

Unlike Europe, China can claim a continuous cultural heritage going back to before 2000 BC. The Chinese have displayed a remarkable talent for making invaders conform to Chinese cultural norms, in contrast to Europe where it was generally the invaded who succumbed to the mores, language and institutions of the invaders. With the possible exception of the Mongols, whom they expelled after a comparatively short period, the Chinese have succeeded in sinofying their foreign overlords, who usually made use of Chinese institutions and adopted Chinese cultural values. In fact, the invaders often became enthusiastic upholders and promoters of Chinese traditions, especially in the fields of art and literature.

It is now thought that the Chinese had been using brushes for painting and writing long before the dawn of recorded Chinese history. Neolithic pottery shows clear evidence of brushwork designs, though the patterns are simple. From the sixteenth to the tenth centuries BC during the Shang dynasty, ideograms began to appear and evolve, though they were probably invented even earlier. There were certainly wall paintings in existence during the Zhou dynasty (c. 1000–200 BC) and evidence of fully fledged brushwork is abundant from the Han dynasty (c. 200 BC–AD 200) onwards. Paper manufacture began during the first century AD and before that there were surely silk and tomb paintings.

The history of painting in China is thus a very long one. It is also very complex. There is a tendency in the West to think of Chinese painting as a homogeneous topic rather like Impressionism or Italian Renaissance painting. In fact, of course, a comparable field of study would be the entire range of European painting from the Greeks and Romans to the present day, taking in all the periods of Spanish, French, Italian, German, Dutch and English painting along the way. At any one time in China there were as many different styles of painting being produced as there were in the whole of Europe.

It is nevertheless possible to trace two broad themes or movements in Chinese painting. These are often referred to as the Academic and the Literary schools, though I personally believe that 'school' is a misleading term in this context. In Europe it is normally applied to a group of painters

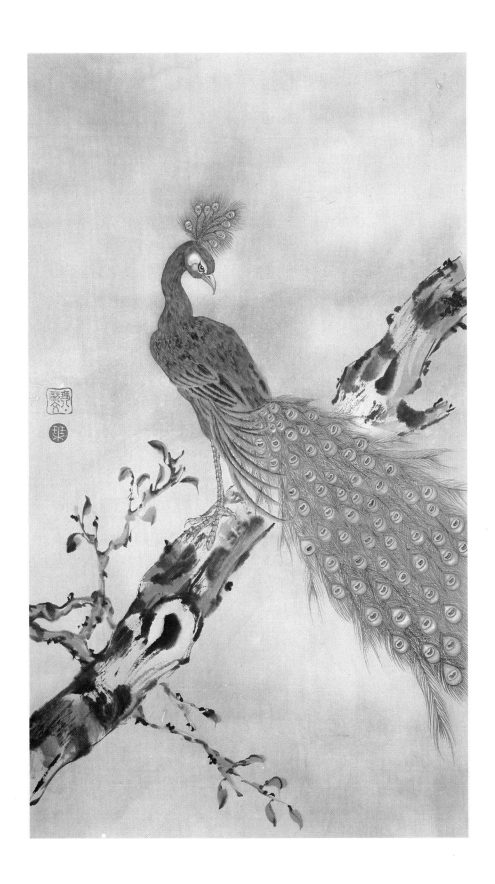

Peacock. *This is a typical example of a painstaking* gongbi *painting. Peacocks are sometimes thought to be unlucky in the West but in the Far East they are a symbol of good fortune*

such as the Pre-Raphaelites. China, too, has had movements and schools of painters in this European sense, but in addition to this all Chinese painting has tended to conform to one or other of the two major traditions, which have transcended and outlived the schools. These traditions can still be found in modern painting. You will be shown how to paint in both these ways in the later part of this book.

During the Han dynasty most painters were probably humble artisans working anonymously for a feudal lord and regarded as fairly low down on the social scale. However, it seems that a different class of Academic painters who enjoyed a much higher social status began to emerge towards the end of the Han, and the tradition of Academic painting, or Huan

Hua Pai, has continued almost uninterrupted until the present. It has been the style of court painters throughout the dynasties, has varied little through the ages, and has its modern proponents today. Described as *gongbi hua*, which can be translated as 'fine style painting', it is painstaking and detailed, requiring a clean line and skilful colour blending. The colour is added as tinting and does not usually form a key element or contribute to the expression of the painting. Every brush stroke is precise. Pictures done in this style tend to be formal and elaborate, and take time to produce.

The other main tradition in Chinese painting is the Literary school, or Wen Jen Hua Pai. Most of today's painters in China and outside it can probably best be seen as descendants of this school. It is characterized by the *xieyi hua*, which can roughly be

Bird in the Snow. *A* xieyi *painting in which the bird is made up of a few expressive strokes*

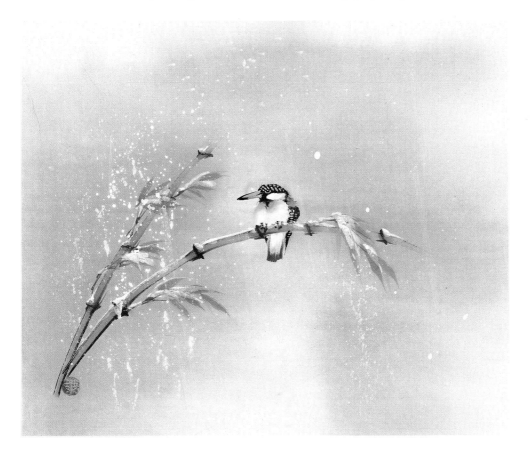

17

translated as 'to write an idea'. It was undoubtedly developed to liberate artists from *gongbi* and its aim is to depict as much as possible in the smallest number of bold strokes. Its style is simplified and free – vital expression is more important than the mere rendering of form. *Xieyi* is much more difficult to master than *gongbi*. A *xieyi* painting should be completed 'in one breath'; in other words, it should be done in one sitting so that the life force is not broken. The term used to describe this rhythmic vitality or harmony with the *chi* is *chi yuen*. As all natural things have an inner spirit, the *chi*, they also have *yuen*, which is the flowing vitality that expresses the *chi*.

A *xieyi* painting should be lively, the brush strokes bold and firm. It should show rhythm and fluidity. A *xieyi* painting must not be merely technically accomplished, however. It can be a compliment to a painting to describe it as *chuo*, or awkward, because this distinguishes it from *chiao*, which means dextrous and clever but lacking in feeling. *Xieyi* paintings should be spontaneous and exciting to look at. A painting should represent the artist's distillation and comprehension of reality rather than be simply an actual representation of it. It should embody his perception of the underlying true nature of his subject.

Most of the innovative influences in Chinese painting have come from the Literary school; even today painters are able to absorb Western ideas and techniques and yet produce works of art that are surely part of an unbroken tradition of expressive Chinese painting stretching back at least as far as the critic Hsieh Ho in the fifth century.

The history of painting in China is very closely allied to the history of thought. Chinese painting is not merely a visual art; it is also a literary and philosophical one. The real roots of Chinese painting can be traced to three philosophies: Taoism, Confucianism and Buddhism. Lao Tse, the founder of Taoism, was born in 571 BC. He was a contemporary of Confucius. Lao believed that men's desires and ambitions were the causes of social unrest and turmoil. He advocated withdrawal and non-interference in the affairs of others. Taoism does not have gods and spirits and there are no benevolent or malevolent beings controlling nature. Lao believed that, 'Heaven and earth are not kind. They treat everything as straw dogs.' Tao is the vital life force in all things and *chi* is its manifest form. The Yin and the Yang are the complementary positive and negative forces, the union of which is essential for creation. From this union came heaven, earth and all natural things. *Chi* is the force which harmonizes Yin and Yang. Everything has its own special characteristic which comes from Tao and all natural things must act according to their Tao: water does not act like rock, the bird does not behave like the fish.

These concepts underlie the fundamental principles of most Chinese brushwork and their embodiment in painting is in turn an expression of Taoist ideals.

It is Taoism that gives Chinese painting its use of space as a positive compositional element. To the Taoist, space is as important as non-space. Lao stated, 'Thirty spokes support the hub of a wheel; because of the space within the hub, the cart is able to move. Vessels may be made of clay; it is the space inside that makes them useful. Build a room with a door and windows; it is the space through the door and windows which is useful.'

Taoism also stresses the virtue of simplicity and this tenet has greatly influenced Chinese life in general and art in particular. The artist keeps his subject simple, trying for a simple effect and for economy of line and colour. Subdued colour is aesthetically pleasing. In Taoist thinking, man's place in the scheme of things is unimportant and artists reflect this by concentrating on natural themes and landscapes, relegating figures to minor roles in these. Taoism is particularly relevant to Literary painting values. The Taoists believed that it was possible for art to get in the way of man's relationship with nature and hence the artist should not strive to achieve beauty at the expense of expression.

A Chinese painting is not representational in the Western sense. It is not a portrayal of a particular bird, animal or flower, but rather a representation of the spirit, or *chi*, of its subject expressed at a moment of time. There is an apocryphal

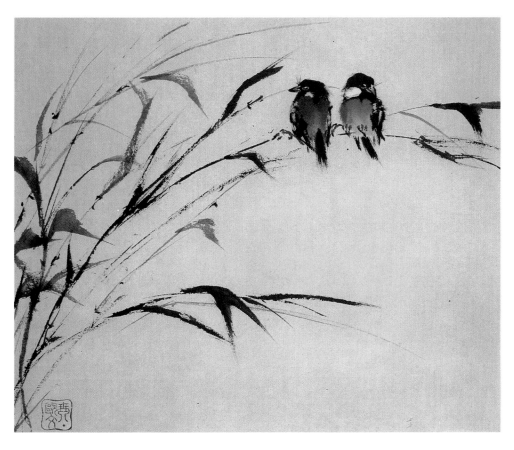

Birds in the Wind. *This painting of two small* xieyi *birds shows how space is used as an important element of the composition*

tale of a European painter and a Chinese painter each being given three days to produce a picture of a duck. They went to the duck pond and sat on a bench. The European spent two of his three days making detailed sketches of individual ducks before spending the third day, still by the pond, producing a portrait of one particular duck on the pond. The Chinese sat and watched the ducks for two and a half days. On the last afternoon he returned to his studio and painted his picture. It was not a portrait of any one specific duck but expressed what he felt was the *chi* of ducks in general.

Confucius, who lived from 551 to 479 BC, took a different view of the world from Lao Tse. He advocated taking an active part in life and was himself energetic in the service of his country. Confucius' teachings have had a profound effect on Chinese culture; they have been widely studied and promulgated, and their influence can be seen in sculptures, monuments and paintings.

Confucius placed great importance on high ethical standards. He stressed duty as the path to harmony. Sincerity of thought and action was the aim of education and knowledge. In Confucianism an artistic training helped to produce men of culture and high moral standards, although Confucius himself did not regard art as important. Art merely served to illustrate the need for order and harmony in life. And he did not even accord painting the status of an art; he saw it as a craft. He was more concerned with the influence on man of music, which he regarded with suspicion. From Confucianism, however, Chinese painting gained a great deal of its formality and adherence to tradition, although Confucianism cannot be said to have contrib-

uted a great deal of originality and spontaneity to Chinese art.

The Buddhist religion was introduced into China in the reign of Han Ming Ti, who ruled from AD 58 to 75. With it came Buddhist painting and sculpture. Chan or Zen Buddhism was established during the seventh century. Zen emphasizes the attainment of nirvana through meditation and has had a great influence on Chinese art. From Buddhism, Chinese painting acquired its meditative mood and the emphasis on the use of black ink. Buddhism also reinforced the importance of simplicity and required painting to be contemplative rather than merely decorative.

All three of these philosophical influences have been at work over the centuries. It is usually possible to detect elements of each of them in a painting, even if one predominates.

Hopefully you will now have an idea of the very rich heritage of Chinese painting and your appetite will have been whetted to try your hand at the very satisfying practical application of the art.

# EQUIPMENT

Successful brush painting requires the correct materials and equipment, and an understanding of the properties of these is essential for their effective use. The Chinese refer to the Four Treasures of painting. These are the ink stick, the ink stone, the brush and the paper. In addition to these, you will need a selection of colours, a

palette to mix them on, and various other materials as described on page 25.

## The ink stick

Chinese ink usually comes solidified into rectangular sticks made of carbon and glue. These sticks are always decorated in some way and some are very beautifully embellished with elaborate coloured pictures. Others have more simple embossed designs or a few characters in gold. Ink sticks vary in quality, some grinding down to give a very

*Two ink stones (one with lid), Chinese and Japanese ink sticks, two seals (chops) and a jar of seal ink*

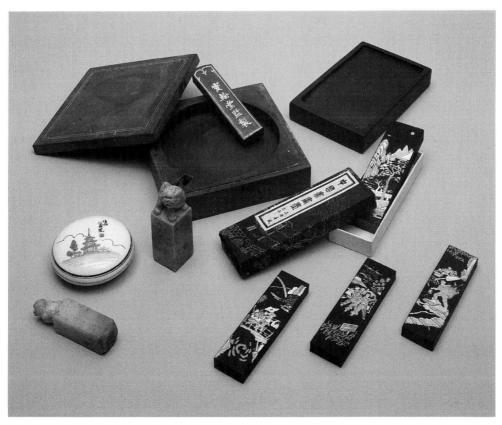

dark, brownish-black ink, others giving a greyer tone. As with most things, it pays to invest in a good-quality ink stick as it will give you a clearer, purer black than a cheap one. You can also use Japanese ink sticks, which have rounded tops and whose quality is sometimes shown by a star coding. It is occasionally possible to buy Chinese ink in liquid form. I do not recommend this, however, because the act of grinding the ink before commencing painting has a calming effect and puts you into a suitable frame of mind while simultaneously loosening up your arm. In any case, some of the bottled inks have a preservative added to them which destroys the non-running properties of the ink. Japanese tubes of ink are usually more reliable in this respect.

## The ink stone

The ink should be ground onto an ink stone. Those available in the West are usually of two types: circular with a lid and a small hole for draining off unused ink; or rectangular with a slope at one end providing a reservoir for ground ink. Both types come in various sizes, but do not get one that is too small as you will not be able to grind enough ink at any one time.

## The brush

A Chinese brush is constructed differently from a Western one. The hairs in a Western brush go down inside the metal clamp, or ferrule, which holds them in place. The head of a Chinese brush, however, is held together with adhesive, which also holds it in the top of the bamboo, wood or bone shaft. Whereas a good Western brush springs back into its original shape after each stroke, the hair of a Chinese brush is carefully selected, graded and arranged so that the brush can either form a fine point or be used spread out or split. A Chinese brush holds much more paint or ink than an equivalent-sized Western brush and, as already explained, can therefore be loaded with up to three tones of ink or three colours at once. No one species provides the hair for Chinese brushes: goat, rabbit, wolf, deer, fox, weasel, pig, badger and horse are all used.

There are three main categories of brush: resilient, soft and coarse. All three catego-

ries come in a full range of sizes. Because of the way it is made, any good resilient brush, regardless of its size, can be used to draw a fine, delicate line. Resilient brushes are used for almost all Chinese painting. They are normally made of wolf, fox or weasel hair and are light brown in colour. Because they are the most versatile and widely used brushes you should equip yourself with at least three: an orchid brush (i.e., one the ideal size for painting orchids), a plum blossom brush, and a bamboo brush. The orchid brush head is thin and about 1 cm ($\frac{1}{2}$ in) long; the plum blossom brush head is the same length but twice as fat; and the bamboo brush head should be about 2.5 cm (1 in) long and firmly padded.

The soft and the coarse brushes are for special effects. To begin with you will not use them, although later you may find you want to invest in different sizes of these, too. Soft brushes are usually made of goat or rabbit hair and are white in colour. They are particularly useful in freestyle painting when a soft, blurred effect is required, as in the breast of a bird or the leaf of a lotus. The coarse brushes are made of horse hair and are dark brown. They are helpful for successful Lingnam-style painting[1] and are used to achieve the ragged effect and bold strokes needed. Since they are very expensive and have to be ordered from Hong Kong (see page 138), you can instead use large, cheap Japanese Inscribe brushes which can be bought from ordinary art shops and which produce a somewhat similar effect.

You will also need a wash brush and a mounting brush. Wash brushes are made of goat's hair, are flat, and have bristles about

1. The Lingnam school grew up in Canton at the end of the nineteenth century. It was founded by Gao Jianfu, who had studied Nanga painting in Japan and who was a political follower of Sun Yatsen. With his brother Gao Qifeng and a friend, Chen Shuren, Gao founded the 'New National Painting' after the 1911 revolution. They introduced contemporary subject matter and used realistic techniques when depicting animals and birds. They also used light effects, shading and perspective. Today the largest group of Lingnam painters is in Hong Kong, and the most influential artist is Zhao Shaoang, a pupil of Gao Qifeng. Most modern Lingnam painters concentrate on bird and flower paintings, and they break with tradition in their use of varied, bright colours.

1 cm (½ in) long. A 2.5 cm (1 in) wide brush is ideal – anything wider is rather unwieldy. A mounting brush looks rather like a wash brush, but its bristles are slightly firmer and longer.

It is vital to buy good-quality brushes. It is not easy, however, to determine how good a brush is when looking at it in the shop. This is because all brushes are sized to keep them in shape before use. Cheap brushes, which look perfectly good when bought, turn out to be padded with inferior-quality hair in the centre once they are soaked. Unfortunately, though perhaps not unnaturally, shops are not well disposed towards customers who try to part the hairs to make sure the quality is consistent throughout! Luckily, however, the price is usually a very reliable indicator of quality, so you should always buy the most expensive brush of its size in the shop.

You must soak the brush in water thoroughly to remove the sizing before using the brush for the first time. Once you have soaked a brush you should never recap it – in fact, some of the better-quality brushes are sold without caps – as this damages the bristles. Brushes should always be washed in water after use and preferably hung point downwards to dry – some have small loops on the end of their handles for this purpose. Brushes not in use should be rolled in a slatted bamboo mat.

## The silk or paper

Chinese painting is done on silk or on *shuan* paper. *Chuan* or silk is sized with a solution of alum and glue to make *hua chuan* or picture silk. Using silk gives a translucent quality to detailed *gongbi* work and enhances the use of colour. Provided the amount of colour used is properly controlled so that the paint does not run along the threads of the cloth, a subtle blending is possible because the paint does not soak in as it does on paper. Silk is less suitable for *xieyi* painting and is almost never used for calligraphy.

The *chih* or paper for Chinese painting and calligraphy is usually called rice paper in English. In fact, it comes in many different qualities, only a few of which are made of rice straw. Other materials from which the Chinese make paper are reeds, hemp, mulberry, bamboo, grass and cotton. Bamboo pulp is generally thought to make the best paper for painting and this kind is the most commonly available in the UK. It is known as *shuan chih* and comes in various thicknesses and qualities, treated with variable amounts of sizing. The more alum sizing used, the less absorbent the paper becomes and the easier the control of the ink. To an artist used to Western watercolour paper, however, even the most heavily sized sheet of *shuan* feels like blotting paper on first acquaintance. The varied absorbencies are used to create different effects. Work done on unsized paper has to be of the 'in-one-breath' style, whereas colour blending and detailed work are best done on well-sized *shuan*.

Grass paper, which is cheap and of intermediate absorbency, is useful for learning, although it is not readily available in the West. Cotton paper and hemp paper are also difficult to buy in the West but give exciting effects in freestyle work. Newsprint is a cheap medium for practising brush strokes at the beginning, although its limitations become fairly rapidly apparent. For example, it is difficult to achieve tonal variation with the ink on newsprint, which tends to make even the blackest ink look wishy-washy, and it also only absorbs paint on immediate impact – any surplus paint on the brush then tends to puddle. In addition, newsprint cannot take a wash or be mounted. It can be very frustrating for a beginner to achieve a satisfying painting of a plum branch, only then to realize that it cannot be mounted and framed.

## Colours

Traditionally, Chinese colours are made from mineral and vegetable pigments. Beginners will need a basic palette of about seven colours: indigo, rattan yellow, burnt sienna, rouge, vermilion, light mineral green, and white. Later you can expand your colour range as you like. It is possible to buy boxed tubes of Chinese painting colour (not to be confused with Chinese oil colour or Chinese watercolour) from Chinese supermarkets, book shops and gift shops. These are reasonably priced but the box contains twelve colours of which you will use only six with any frequency. As the

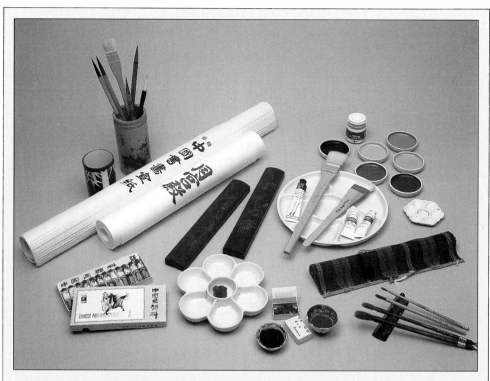

*Some Chinese brush painting equipment*

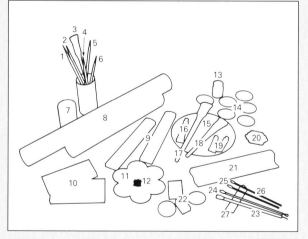

1 Horse-hair brush (unused)
2 Horse-hair brush (unused)
3 Japanese wash brush
4 Japanese Inscribe brush (unused)
5 Resilient brush, bamboo size (unused)
6 Medium soft brush (unused)
7 Water jar
8 Paper
9 Pair of paperweights
10 Box of Chinese painting colour
11 Palette
12 Lump of Chinese rattan yellow
13 Pot of gouache white
14 Japanese Teppachi colours
15 Palette (fondue plate)
16 Gouache colour
17 Mounting brush
18 Chinese wash brush
19 Gouache colours
20 Small palette
21 Bamboo mat brush holder
22 Chinese colours: chips in boxes and
    diluted chips in bowls
23 Bamboo brush

24 Plum blossom brush
25 Orchid brush
26 Small orchid brush
27 Brush rest

tubes are small these six will soon run out. It is better to try to obtain solid colours, which are occasionally sold in Chinese shops and can be ordered from Hong Kong. Apart from yellow, Chinese solid colours come either as cakes in ceramic dishes or as small chips of colour in boxes. These chips should be put into a dish and dissolved with hot water to form a cake. Some mineral colours come in powder

form, but I do not recommend these as mixing them is quite complicated. The yellow, which is solidified rattan sap and which is slightly poisonous, comes in rough lumps of variable sizes. To use it, simply moisten a lump with a wet brush. You should eschew the very expensive boxed sets of colour sticks that can often be bought in art shops which sell Eastern materials – not only are these sticks costly, but you would also need a great many ink stones to grind them on.

Most art shops in Britain sell Japanese colours, which come in flat ceramic dishes and provide a very practical solution to the supply problem. Unfortunately some of the colours are not the same as the Chinese ones so, for example, you will have to substitute ultramarine for indigo and cloe-seed yellow for the rattan. The red, which is called bloddy red, has a bluer tone than its Chinese counterpart.

You can use ordinary Western water-colours to practise with, although pictures painted with these cannot take a wash or be mounted. A pot of poster or gouache white makes a satisfactory substitute for Chinese lead white. Other gouache colours also work well if you cannot obtain the Chinese or Japanese pigments. They have fixing qualities similar to Chinese colours but lack their translucency. This comparative lack of delicacy does not necessarily matter; indeed, it can be an advantage in the kind of freestyle paintings that use many bright colours.

## Palettes
Also necessary is a white china palette, preferably one divided into fairly large sections. Most watercolour palettes sold in art shops in Britain have very small subdivisions which are not very useful for loading sequences of colour onto a brush or for mixing washes. Some Chinese shops sell purpose-made dishes about 20 cm (8 in) in diameter and divided into sections. Even better, however, in that they are larger with different-sized sections, as well as being cheaper and more accessible, are plates sold in china and kitchen departments for

fondue. You should avoid colours and patterns on these though, since they make ink and colour tones difficult to distinguish. Empty Japanese colour dishes also make useful mixing dishes.

## Other necessary equipment
You will need a sizeable, steady table at a comfortable height for working. You should also have good light, preferably daylight. In addition, you need a water jar; a roll of toilet or kitchen paper; a bamboo place mat for storing brushes when they are not in use; and a blanket for placing under pictures when applying a wash. A large piece of felt, preferably white to avoid colour distortion, is probably the best material to put under the paper to absorb excess moisture. However, newspaper is perfectly adequate for this purpose. For some reason *shuan* paper, unlike your fingers, will not pick up printers' ink.

## Useful but not essential equipment
There are a few items of equipment that are not vital but which will simplify your life or enhance your painting. Paperweights fall into this category, preferably the long, thin Chinese ones specially designed for painters and calligraphers which are sold in pairs. A pot for holding brushes while they are in use is also helpful. However, this should not be used as a permanent storage place because it holds the brushes upright, allowing moisture to collect at the base of the hair and loosen the glue. You can also buy brush rests at a number of Chinese and Japanese shops. When mounting, a large table with a wipeable surface, such as Formica, simplifies the task greatly.

Your finished paintings will be very much enhanced by a chop, or seal, which it is now possible to have carved in London (see page 138). A chop is usually applied with red ink and can be made to represent a name or a suitable phrase.

Now that you have your brush and your ink, you are ready to begin a great adventure.

# MAKING A START

While there is obviously no substitute for watching a teacher perform the brush strokes and mix the ink, and then attempting the techniques yourself, this book is meant to provide the next best thing to traditional lessons in Chinese brush painting. You should regard the book as providing a course and try to master each stage before going on to the next.

The Chinese method of learning anything, be it painting or kung fu, can be broken down into three steps: watch; do; understand. You can learn by imitation and repetition until finally the *chi* flows through you and you understand. In other words, you should not worry about *why* you are doing something – its purpose will become clear in time. In this book I have tried to give instructions to cover the watching and imitating stages; the rest is up to you.

In Chinese brush painting there is a logical sequence of learning, evolved over centuries, which will enable you to build up your repertoire of brush strokes just as a trainee instrumentalist builds up his repertoire of notes and scales. *The Mustard Seed Garden Manual of Painting* (1679–1701) has advice for the would-be painter on the need for being methodical:

He who is learning to paint ... should begin to study the basic brush stroke technique of one school. He should be sure that he is learning what he set out to learn, and that heart and hand are in accord. After this, he may try miscellaneous brush strokes of other schools and use them as he pleases. He will then be at the stage when he himself may set up the matrix in the furnace and, as it were, cast in all kinds of brush strokes of whatever schools and in whatever proportion he chooses. He himself may become a master and the founder of a school. At this

later stage, it is good to forget the classifications and to create one's own combinations of brush strokes. At the beginning, however, the various brush strokes should not be mixed.[1]

Even Fang Zhaoling, who is one of the most innovative Chinese painters working today, exhibiting in the USA, the UK, Hong Kong and China, recognizes that it was vital for her to have a thorough grounding in basic brushwork. She spent ten years studying under Zhao Shaoang of the Lingnam school before she felt the need to break away and the confidence to express herself by creating her own style.

The best way to learn is to practise each stage thoroughly. You must be patient, however, and prepared to work hard. Only by constant practice will you learn to paint with confidence and ease.

Do not let yourself become discouraged during these early stages. At first you may feel that you will never progress beyond the basics, but it is vital to be most thorough at the beginning or you will never achieve the facility and effortlessness that are the hallmarks of a successful brush painting. Eventually you will be rewarded by finding that later lessons take less time to learn. In any case, the learning process is a continuous one: my own teacher claimed he was still learning after fifty years.

One of my students related a no-doubt apocryphal story she had heard about a man who went to a famous Chinese painter to commission a picture. He was told to come back a year later and this he duly did. On

1. Facsimile of the 1887–8 Shanghai edition, translated and edited by Mai-Mai Sze, Princeton University Press, 1977.

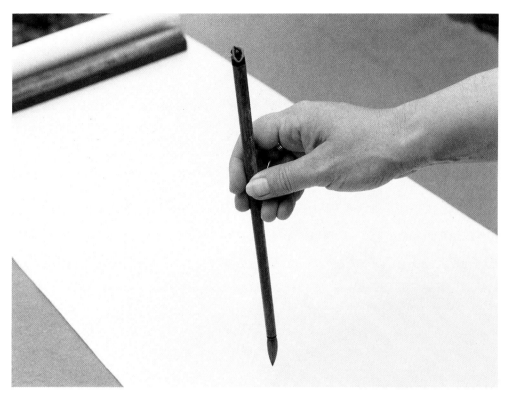

*The correct way to hold the brush*

seeing his customer, the painter got out paper, brush, ink and ink stone; he ground the ink and in a few strokes completed a painting which was exactly what was required. The customer was mystified and enquired about the need for a year's delay. Without a word, the artist got up from his seat at the table and opened a cupboard in a corner of the room. It was full of practice versions of the painting on the table.

Before you begin to paint, there are several general points you should always remember. First of all, try to be in a calm and contemplative frame of mind. Take time over preparing your materials; make sure that your physical environment is soothing; shut yourself away in a quiet corner (the kitchen table with children underfoot clamouring for tea is not to be recommended). Enjoy the process of getting ready to paint before you actually start the painting itself.

You should always strive for sureness and boldness in your brush strokes. Even when the subject of your painting is small and detailed, the individual brush strokes should be deft and certain. This may result in somewhat unkempt results to begin with, but you should remember that the Chinese admire paintings that are *chuo*, or awkward, and are scathing about those that are dextrous but lack feeling. In time you will find that you gain control over the brush and can make it do what you want without losing any spontaneity.

When you are learning by copying it is important not to be too slavish about it. A very common mistake is to continue to look at what you are copying while actually painting. This results in a hesitant line. You should look at the subject before putting brush to paper and then reproduce an impression of it from memory. To help you to achieve spontaneity and feeling in your painting you should always use as large a brush as it is practical to use for any given subject. This encourages you to use fewer strokes.

## Holding the brush correctly

A Chinese brush is held quite differently from a Western one. It should always be

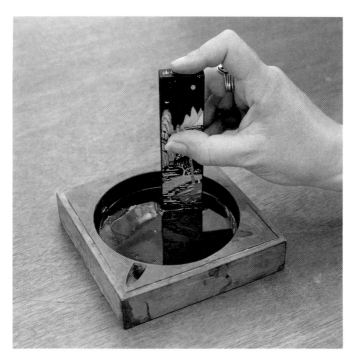

*Use a circular motion to grind the ink*

held as upright as possible, between the thumb and the middle finger with the other three fingers providing guidance rather than support, the index finger in front of the brush and the ring and little fingers keeping it upright from behind. The brush should be loosely held, not tightly gripped. For small details you may hold it fairly close to the bristles, but larger, freer strokes are done with the brush held quite high up the haft. The movement of the strokes comes from the shoulder, not from the wrist, so you should ensure that you are sitting or standing in a relaxed but upright position, with plenty of freedom for your shoulder to move.

## Grinding the ink

It is crucial to grind your ink black enough: nothing mars the effect of a picture so much as poor ink values. You should grind your ink stick from the bottom – you can work out which end this is from the calligraphy or picture on the side of the stick – for the ink at the top of the stick, where you hold it, is often less dense. Some experts claim that distilled water should be used for grinding ink but this is not normally done. Put a few drops of water onto the grinding surface of the ink stone and holding the ink stick upright, grind it with circular movements until the motion leaves a dry patch on the stone. This indicates that the water has absorbed as much ink as possible. However, you should always test the ink to make sure that it is a good, rich black. Take care not to leave the ink stick upright on the stone because the moistened glue within it will cause adhesion.

Grey tones are achieved by placing a small amount of black ink on a china palette and diluting it to the desired shade with water. Some subjects require a great deal of ink, others less. It is a common fault of students not to grind enough ink and to try to stretch it too far by overdiluting.

## Composition

Be careful about composition. Allow yourself a piece of paper that is larger than you think you will need. This should help you to avoid a tendency some people have to make their subjects too small and therefore rather cramped. However, you must also avoid the opposite temptation, which is to fill the paper completely. Remember that space is an essential element of composition in Chinese painting. Westerners tend to worry about unused space in paintings and seem to have a distressing need to fill it, but you must learn to curb this desire when you are brush painting.

The amount of space devoted to individual subjects in this book is not necessarily indicative of the amount of practice they demand. It is simply that as you progress through the course, I shall assume a certain knowledge has already been acquired, allowing later subjects to be dealt with in less detail.

For most topics I begin by considering what is often called the 'outline', or contour, method and then go on to discuss the 'freestyle' technique. This distinction is useful for explanatory purposes, but no painting need be done exclusively in one or other method. For example, outlined flowers will often be accompanied by freestyle leaves, or an outlined bird will be perched on a freestyle branch.

# PAINTING PLUM OR JADE BLOSSOM

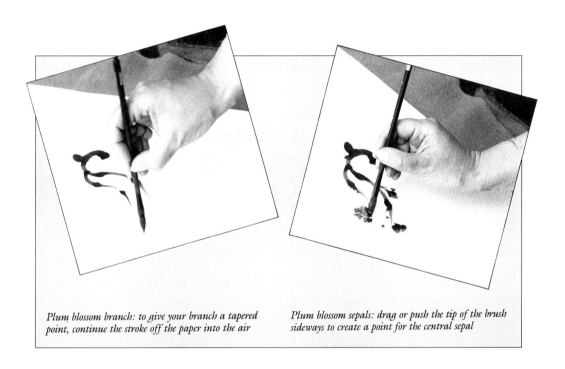

*Plum blossom branch: to give your branch a tapered point, continue the stroke off the paper into the air*

*Plum blossom sepals: drag or push the tip of the brush sideways to create a point for the central sepal*

Many people expect to start by painting bamboo. However, traditionally the first of the Four Friends (plum, bamboo, orchid and chrysanthemum) attempted by students of Chinese painting is plum or jade blossom. It is in fact logical to begin with this because the execution of plum blossom calls for several skills that are needed for every aspect of brush painting. For example, painting plum blossom will require you to control the tone of your ink and the amount of moisture on your brush. In addition you will find that the drawing of plum blossom is greatly facilitated by hold-ing the brush correctly, so you will there-fore, hopefully, acquire good habits right from the beginning. You will also learn dry and wet brush techniques when doing branches and will discover the value of working quickly and deftly to obtain a spirited effect.

What is normally referred to as the plum or jade blossom of Chinese painting is in fact usually the Japanese apricot. It is a symbol of winter and is much admired in China. Gardeners tend the trees with care; poets extol its beauty and purity in words; and painters strive to capture its *chi* on

paper. According to tradition, the blossoms themselves are the Yang and the trunk and branches the Yin; the three sepals are heaven, earth and man; and the five petals are the elements. The stamens represent the planets.[1]

## Flowers: outline method

To paint plum blossom, first grind your ink. Then take a medium-sized, plum blossom brush and with it transfer a small amount of ink to your palette. Still using the brush, add water gradually until you have a reasonable quantity of grey ink.

Rinse and dry your brush. Beginners often forget to do this, but it is very important. If you do not dry your brush, the water that has accumulated at the base of the bristles while you have been mixing your ink will run down to the tip and hamper your painting.

Using just the tip of your brush, dip it into the grey ink and gently wipe off any surplus on the side of the palette, keeping the point of the brush intact.

Holding the brush upright between the thumb and the middle finger as described on page 27, practise drawing slightly elliptical circles about 8 mm ($\frac{1}{3}$ in) in diameter. Use even pressure and remember to keep the brush upright all the time. This will ensure that you move the whole brush rather than just tilt it, which would result in an outline of uneven thickness. If the tip of your brush inadvertently misses the paper at any point, do not attempt to go back and fill in – simply leave the gap and let the viewer's eye supply the continuation.

When you feel you can achieve a uniform line, start joining your shapes together to build up a flower as illustrated in figure 1. Begin with the complete petal in the centre, making your taking-off point the place from which you are later going to paint the central sepal. Next, do the two petals on either side and fill in the remaining two petals.

For the stamens use black ink. Starting nearest the petal edge and working from

your shoulder, do a quick flicking stroke, using just the tip of the brush. To make the stamen taper to a point, continue the stroke off the paper into the air. Start with the centre stamen and always try to have either seven or nine on each flower. The pollen is dabbed on in a random manner.

The sepals are done last. Use very black ink and soak the brush with it about half-way down. The two sepals on either side are formed by placing the tip of the brush on the paper and pressing it down sideways for a moment before lifting it off cleanly. To form the one in the middle, begin in the same way, but after pressing down you must pull the brush down or up (depending on the angle of the flower – see figure 2) so that it leaves a tail as it comes off the paper. A very common beginner's mistake is to try to draw a comma shape with the tip of the brush. In fact, the point is actually made, not by the tip of the brush, but by the side as it comes away from the paper.

1. *The Mustard Seed Garden Manual of Painting* (1679–1701) provides a more detailed discussion of the symbolism of the various parts of the plum plant, as it does for other subjects.

*Figure 1 Building up a single outlined plum blossom flower*

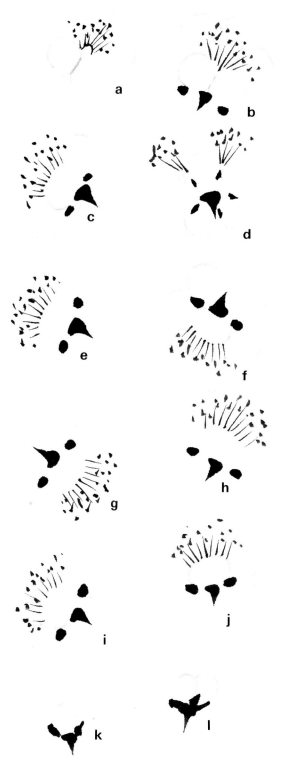

Once you have mastered this basic flower, try the varying shapes and angles in figure 2, known as the twelve traditional faces of plum blossom. With **a** and **b**, start by drawing two circles side by side, beginning and finishing each brush stroke at the bottom. Then draw in the three semi-circles. For **c**, begin as you did for the basic flower but omit the last two petals. For **d** there are only semi-circular petals and the five sepals are formed by the tip of the brush being placed on the paper appropriately. Flowers **e** to **j** are all variations on figure 1 showing differing angles and with the stamens and sepals in various positions. Remember to begin your complete petal from the point where you will join the centre sepal. The buds, **k** and **l**, have slightly smaller petals than the open flowers and these are somewhat egg-shaped, but the principle of painting them is the same.

## Flowers: freestyle method

When you have mastered the outlined flowers you should try a freestyle one (figures 3 and 4). This looks easier but is

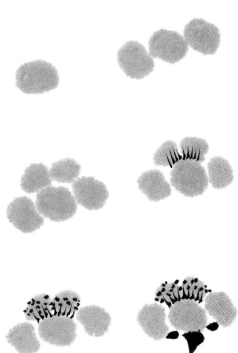

*Figure 2 The twelve traditional faces of plum blossom done by the outline method*

*Figure 3 Building up a single freestyle plum blossom flower*

31

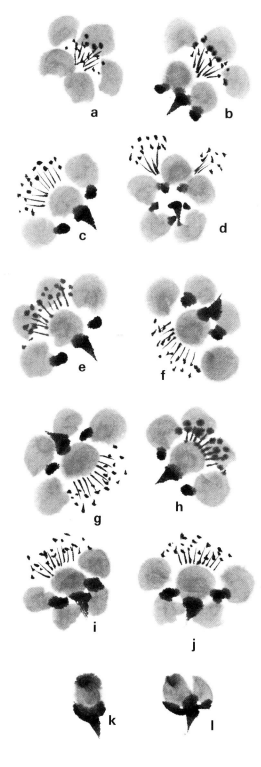

a    b

c    d

e    f

g    h

i    j

k    l

*Figure 4 The twelve traditional faces of plum blossom done by the freestyle method*

actually harder to do than an outlined one, so do not despair if your early efforts resemble cats' paw prints. Once again, begin with an ink stone full of very black ink. As before, take some ink and dilute it to make grey, but note that this time you will need a lot more grey ink. Do not forget to rinse and dry your brush after mixing the ink tones.

The petals are done in the same order as before, but they are formed as a solid shape. First, soak your brush in the grey ink and wipe off the excess on the side of the palette. Holding the brush upright, place the tip on the paper and then press down while rolling the brush round, either completely or half-way, depending on which petal you are doing. The tip of your brush thus forms the centre of your petal and the petal edge is described by the heel. This needs to be done quickly, otherwise your ink will spread too much and the edges of your petals will be too blurred. Try to keep your petals close together without allowing them to merge.

The stamens, pollen and sepals are done in the same way as before, with very black ink. It is best to do them before the petals have dried so that they will blend in slightly with the lighter ink.

## Branches

As with the flowers, plum branches can be painted using either the outline or the freestyle method. Either kind of blossom can be used with either kind of branch. Freestyle branches are best done standing up as this will give your arm the freedom to move properly.

The following four examples (figures 5–8) illustrate various techniques used in painting plum blossom branches. For figure 5 you should grind plenty of ink and have your brush full and fairly wet. Using the whole brush and without taking it off the paper, execute each branch as quickly as possible. Make the joints by pausing slightly, and the thicker parts of the branch by pressing with more of your brush. At the end of a branch you should pull the stroke into the air as you did for the stamens, to give your branch a tapered point. If you want the end of the branch to be blunt, simply stop the stroke abruptly and lift the

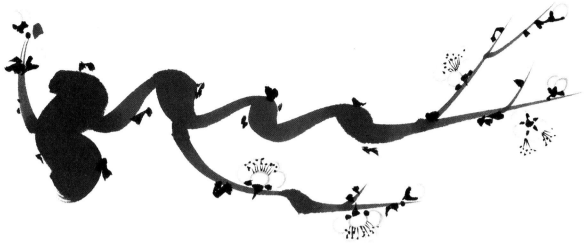

*Figure 5  Plum branch worked with a wet brush and varying pressure*

brush cleanly off the paper. When your branch is complete, add some random dabs of very black ink to represent lichen or moss.

Figure 6 is worked with a slightly drier brush. The thick main branch is made by holding the brush sideways on and pulling down, but as you move along the branch, you should adjust the angle of the brush head until it is being used in the usual way with the stroke going the same way as the bristles. Use the same technique for the side branches as you did for the small branches

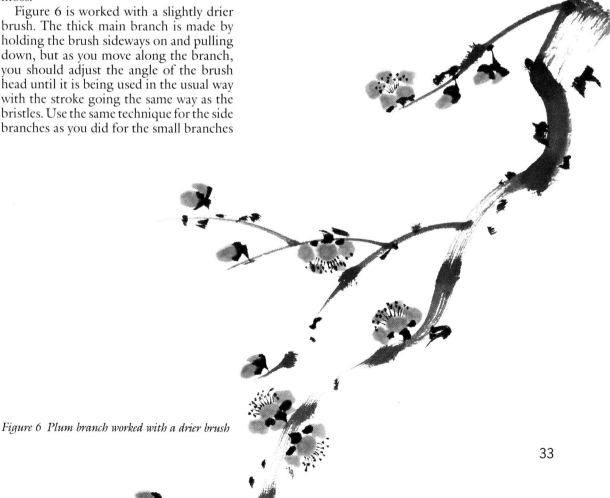

*Figure 6  Plum branch worked with a drier brush*

33

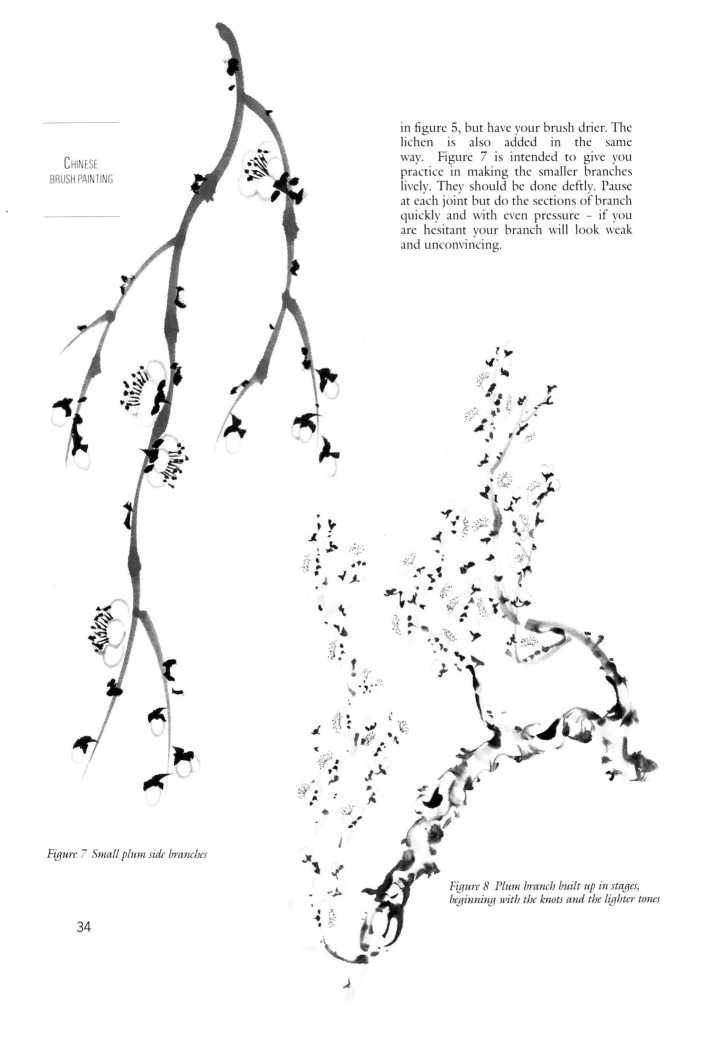

in figure 5, but have your brush drier. The lichen is also added in the same way. Figure 7 is intended to give you practice in making the smaller branches lively. They should be done deftly. Pause at each joint but do the sections of branch quickly and with even pressure – if you are hesitant your branch will look weak and unconvincing.

*Figure 7  Small plum side branches*

*Figure 8  Plum branch built up in stages, beginning with the knots and the lighter tones*

34

Figure 8 is built up gradually, starting with the knot holes which are the focal points. To do these use a stroke similar to that used for the centre sepal. After the knot holes the light shading is done and, lastly, the darker outlining. Keep your brush lively and vary the pressure so that you impart texture and shape to your branch. The small branches are worked as in the previous three examples and so is the lichen.

## Using colour

Plum blossom is usually painted in colour and figure 9 shows various colour schemes which can be used for the flowers. For the outline flowers (**a**), first put a watery white wash over the petals. While this is still wet, blend yellow into the centre of each flower with the tip of your brush. You can use ink for your stamens and pollen or you can do the stamens in vermilion and the pollen in thick yellow, vermilion and red.

For the freestyle flowers (**b**), take a clean brush and dip it first into clear water. Wipe off the excess on the edge of the water jar and then just tip your brush into red. Paint the blossoms as you did when using ink. The effect of the water on the brush is to give two-tone petals as the colour will bleed slightly into the clear portion of each stroke. Again, you can do the stamens in ink or in vermilion and the pollen in ink or in colour. For a slightly different two-tone effect you can fill your brush with watery white instead of clear water before tipping it with red (**c**). Obviously if you want uniform-coloured freestyle petals you simply fill your brush with light colour instead of ink. The sepals are always done in very black ink.

Freestyle branches do not have colour applied to them, but the outlined ones can have a light brown wash. To achieve this, press down with the heel of the brush while gently moving the tip. Try to blend more than one shade onto the branch.

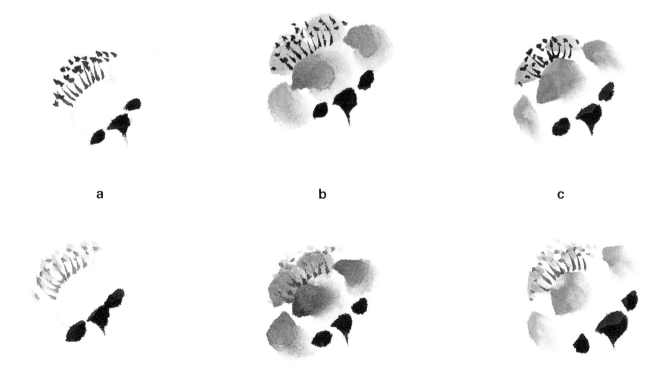

a          b          c

*Figure 9 Colouring for plum blossom flowers*

## Common mistakes

Figures 10 and 11 are intended to show some of the mistakes commonly made by beginners. In figure 10a the brush was not dried after mixing the ink and before being redipped to start the petal, so the ink has blurred too much; in **b** the stamens were not tapered by lifting the stroke off the paper into the air, and the sepals were drawn too deliberately; and in **c** the petal was drawn rather than formed by the brush being rolled: a white spot in the middle of the petal is the result. Figure 11 shows what can happen when you are too hesitant with your branches and when you do not pause at the joints: the branch is thick and jointed to the next one by a very flimsy thread.

*Figure 11 The joints of this plum blossom branch are stiff and unconvincing*

When you have practised sufficiently to be confident of avoiding these faults and when you have executed a few lively and spirited plum blossom paintings of your own, try a more elaborate and complicated one such as the one illustrated in figure 12. Once you have done a plum blossom painting that is to your liking, you should turn to the chapter on washes (see page 115) and try your hand at a simple one. Figure 12 has a wash consisting of a combination of assam tea and green tea. It was done on the back of the painting, which was laid on an old blanket and damped before the wash was applied with light strokes, taking care to vary the direction of the brush and to create only subtle colour variations.

Now that you are reasonably confident with plum blossom you are ready to go on to bamboo.

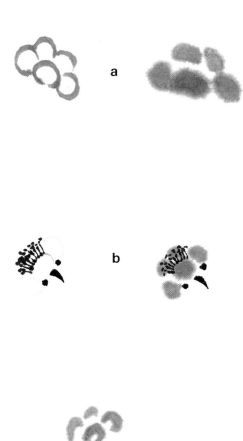

*Figure 10 Some common mistakes when painting plum blossom flowers*

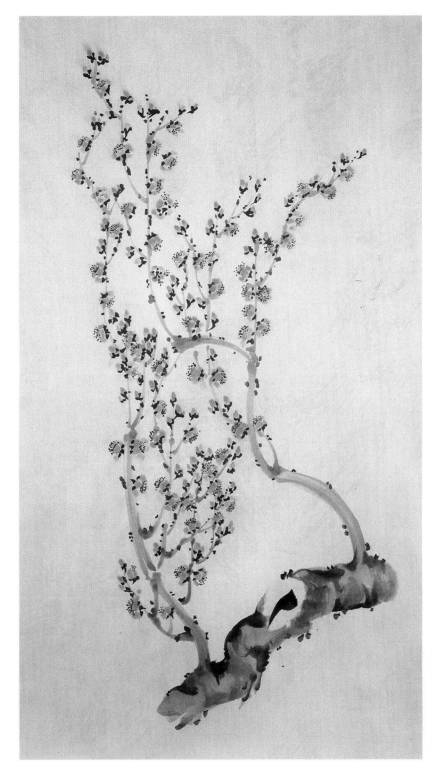

*Figure 12 Finished plum blossom painting with a tea wash. The flowers are painted without
using white and the branch is given a simple brown wash before the tea is applied*

# PAINTING BAMBOO

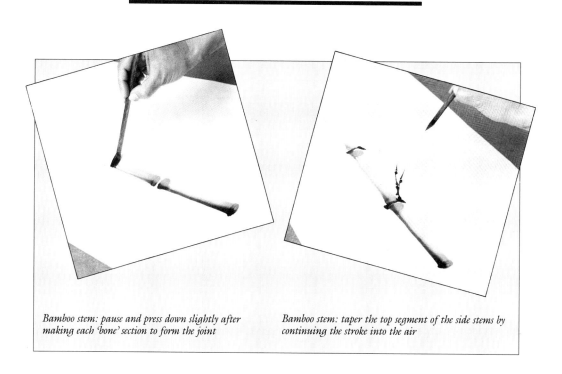

*Bamboo stem: pause and press down slightly after making each 'bone' section to form the joint*

*Bamboo stem: taper the top segment of the side stems by continuing the stroke into the air*

Bamboo is the gentleman of the Four Friends. The Chinese regard it as virtuous, hardy, upright and gentle; it is also humble and consistent, the last because it grows throughout all four seasons. The painting of bamboo is second only to landscape in prestige and is infinitely more important than the painting of animals or birds. A successful bamboo painting is almost the quintessence of Chinese painting.

You should try to visualize the whole before putting brush to paper and you must complete your rendering 'in one breath', using the minimum of strokes and the maximum of élan. The ability to do good bamboo is a very reliable indicator that you will in time be able to master the techniques of Chinese brush painting fully.

## Stems

Bamboo is very greedy for ink so you must begin by grinding plenty. You should also make an ample quantity of grey. Use a large brush and remember to rinse and dry it after using it to mix the grey and before you load it to begin painting.

To do a thick bamboo stem as in figure 13a, first saturate your brush with grey. Wipe off the excess moisture on the edge of your palette and tip the brush in black. Then, using the side of the brush, make your stem sections about 6–7 cm (2½–3 in) long. Bamboo is always painted as it grows, i.e., from bottom to top. Pause slightly at the beginning and end of each stroke and move the brush quickly in the middle. This is known as a 'bone' stroke. Leave a small

gap after each section and repeat the stroke again. Make the segments at the top slightly shorter than those at the base, and when you reach the top segment taper it off by continuing the stroke into the air as you did with the ends of the plum branches. You must never redip your brush in mid-stalk; do not worry if the brush 'misses' occasionally as this will add texture. In fact, as you become more skilled you can try to do your stems with a drier brush and create this effect deliberately (**b**). If you do not want the two-tone effect you need not tip your brush with black before beginning.

For the narrower bamboo stem (**c**), take the same brush and again dip it in grey,

wiping off the excess moisture. Holding the brush upright and again working from the bottom, make your segments in the 'bone' manner, pausing slightly at the beginning and end of each stroke but moving fast in the middle. This time, however, your strokes are done in line with the bristles, not across them. Use the whole of your brush and make the segments rather longer than you did with the thicker stem. Remember to taper the top segment. The dark outline can be created by gently stroking the sides of your brush in black before starting the stem.

Stems can also be made without breaks, using the brush sideways (**d**) or lengthways

*Figure 13 Bamboo stems*

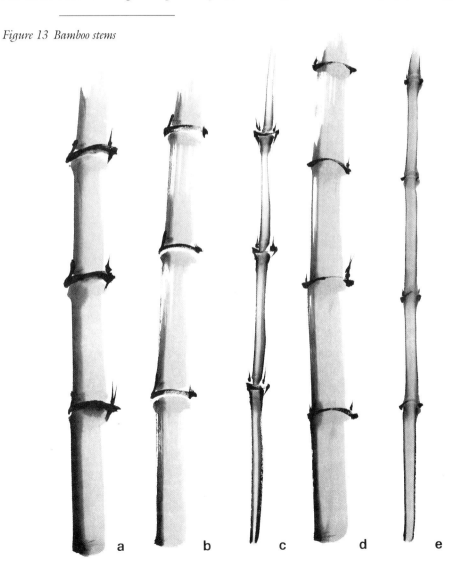

a　　　b　　　c　　　d　　　e

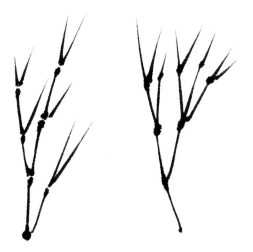

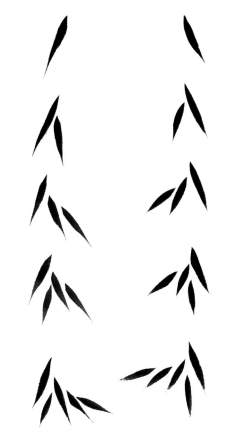

*Figure 14  Small bamboo side stems*

(**e**). Fill the brush as before and start as for the previous example, but instead of pausing at the end of each segment and lifting your brush, do a sideways squiggle while still working at the same speed. This will become the joint.

Figure 14 illustrates the small side stems. These grow out of the joints and are painted with the tip of the brush. Usually they are done with short 'bone' strokes with tapered final segments. Stems growing out of gapless bamboo such as in figures 13**d** and 13**e** are done without lifting the brush between sections; to do these, pause and go back slightly instead.

The joints on the bamboo stem should be added while it is still wet, using very black ink. They are done fast and, though there is a variety of shapes possible (see figure 13), you should be consistent within one picture.

## Leaves

Bamboo leaves are not as easy as they look. There is no substitute for plenty of practice. When I was first learning to do bamboo I filled enough rolls of paper to cover the walls of a sizeable room with nothing but leaves.

First of all, saturate your brush with ink and wipe off the excess on the side of your palette. Hold the brush loosely about half-way up and keep it upright. Paint each leaf in one swift motion – down, along, up –

*Figure 15  Typical bamboo leaf formations. Each leaf should be painted in one fluid movement*

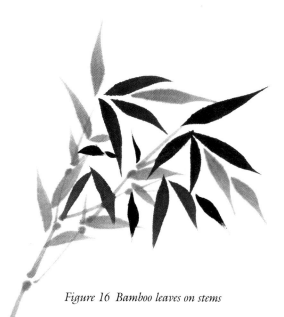

*Figure 16  Bamboo leaves on stems*

40

starting and finishing the stroke in the air. Do not worry if the end splits; this is not a serious fault provided the leaf has form (it may even on occasion be the desired effect!). Bamboo leaves tend to get larger the further they are from the base of the stem on which they are growing. Practise the formations in figure 15 and then try putting leaves onto the stems (figure 16). Do the blackest leaves first and then the lighter ones, otherwise the black ink will run into the grey too much. Figure 17 shows how a complete bamboo stem is built up.

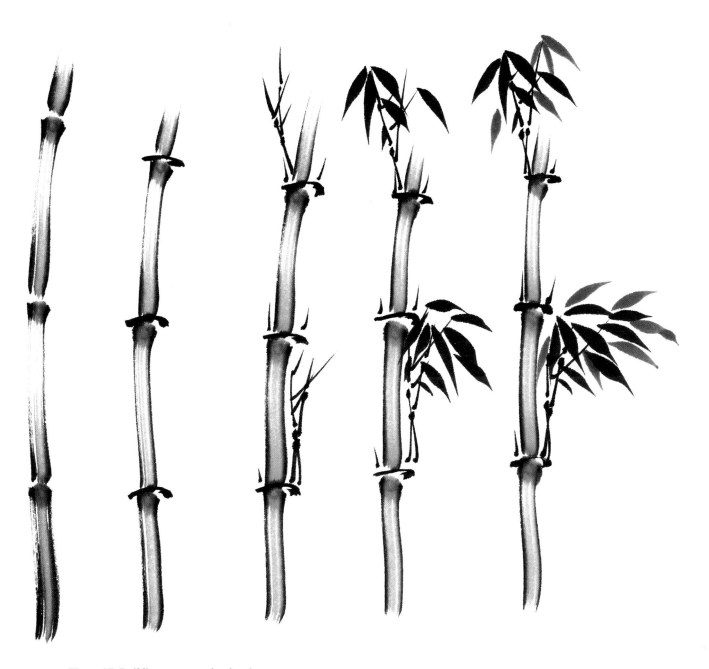

*Figure 17 Building up a complete bamboo stem*

## Common mistakes

While most students master bamboo stems fairly readily, a few typical faults do crop up. In figure 18a, for example, you can see that the joints are just arbitrary gaps because the brush pressure was too even; in **b** the brush was too wet and the stem was painted too slowly; and in **c** the brush was hesitant and the stem segments were made too long – the result looks flat and unconvincing. Leaves usually cause problems at first for most beginners. The commonest errors are the two shown in figure 19: in **a** the stroke was carried on too long; and in **b** the movement of the branch was not fluid, resulting in a pause mid-leaf and a quick flick for the leaf tip.

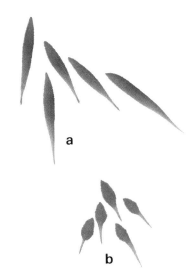

*Figure 19 Some common mistakes when painting bamboo leaves*

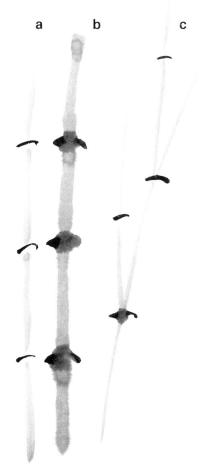

*Figure 18 Some common mistakes when painting bamboo stems*

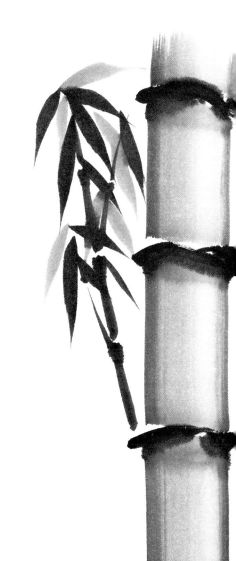

*Figure 20 Fish made up of bamboo leaf shapes*

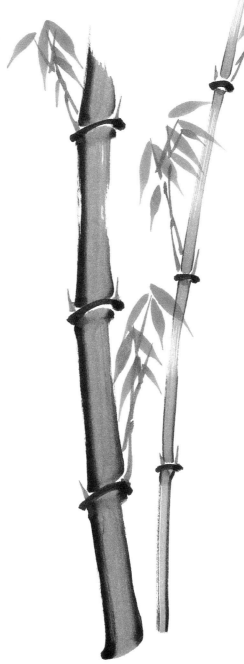

You cannot practise bamboo leaves too much, but you may find the process slightly tedious after a while so try putting the leaf shapes together to form other things, such as the fish illustrated in figure 20.

If you want to try some very dramatic bamboo, as in figure 21, use your wash brush. Soak the brush in light grey and then stroke the sides in black. The stem is then done in the same way as for figure 13c.

Obviously bamboo can also be done in colour – the technique is exactly the same. Figure 22 gives an example.

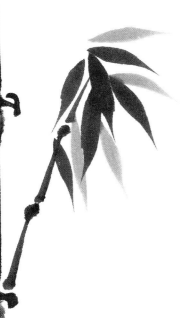

*Figure 21 Wide bamboo stems executed with wash brushes*

*Figure 22 Bamboo in colour. Notice the use of space in the composition. The picture is very simple yet it is satisfyingly complete*

43

# PAINTING ORCHIDS

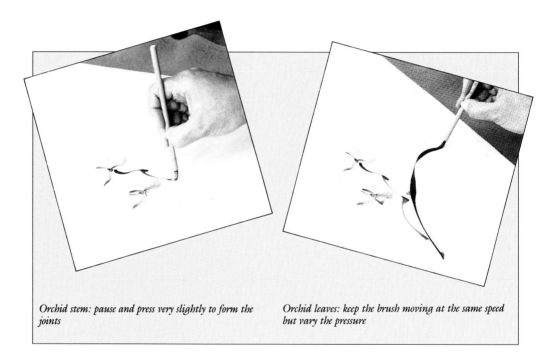

*Orchid stem: pause and press very slightly to form the joints*

*Orchid leaves: keep the brush moving at the same speed but vary the pressure*

The orchid is believed by the Chinese to symbolize serenity in obscurity. Its perfume is highly prized, the more so because the flower tends to grow in inaccessible forests. It is essentially a feminine plant.

## Flowers
Begin by painting the flowers. Figure 23 indicates the order and direction in which you should paint the petals. First, dip your orchid brush in grey ink and wipe off the excess on the edge of your palette. Tip the brush in black ink. Start with the two central petals, **a** and **b**, pulling the brush in the direction of the arrows. You can always tell where the stroke was begun by the darker tone caused by the initial contact of the darkened brush tip with the paper. Next

do petal **c**, this time beginning from the centre of the flower. Pull the brush outwards with just the tip in contact with the

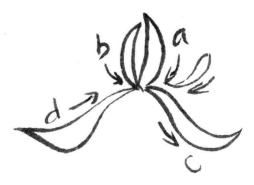

*Figure 23 The order and direction in which orchid petals should be painted*

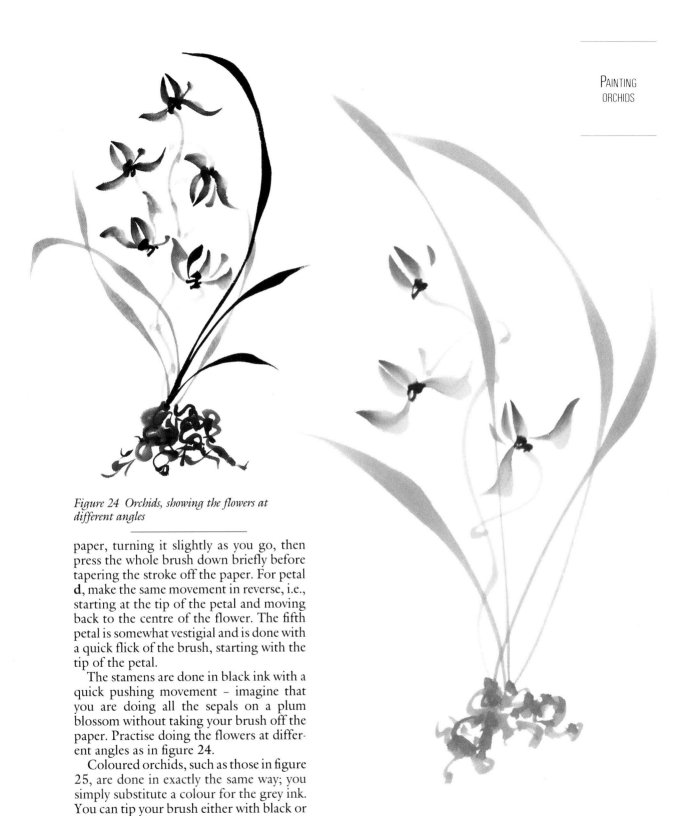

*Figure 24 Orchids, showing the flowers at different angles*

paper, turning it slightly as you go, then press the whole brush down briefly before tapering the stroke off the paper. For petal **d**, make the same movement in reverse, i.e., starting at the tip of the petal and moving back to the centre of the flower. The fifth petal is somewhat vestigial and is done with a quick flick of the brush, starting with the tip of the petal.

The stamens are done in black ink with a quick pushing movement – imagine that you are doing all the sepals on a plum blossom without taking your brush off the paper. Practise doing the flowers at different angles as in figure 24.

Coloured orchids, such as those in figure 25, are done in exactly the same way; you simply substitute a colour for the grey ink. You can tip your brush either with black or with a darker tone of your basic colour.

*Figure 25  Orchids in colour*

## Stems

The stalk of the orchid must be done with speed and control, using light ink. As you did with small plum branches, pause slightly to make the joints. The method for doing the orchid stem is an exception to the rule that things should always be painted in the direction they grow. You will find it much simpler to begin your stem at the top flower and work down towards the roots. Join the side flowers after you have done the main stem.

## Leaves and roots

The leaves are done by varying the pressure of your brush. Load the brush fully with grey or black ink, depending on which leaf you are doing. Do the black ones first to avoid bleeding. Keep the brush moving at the same speed throughout the stroke, pressing down and lifting it as you go. Taper the end of each leaf. The roots are done with a twisting movement of the brush, using grey and black ink.

## Common mistakes

More than almost any other subject in Chinese painting, orchids are a knack that will come with sufficient practice. There are not many typical faults in orchid painting, but figure 26 shows a few that might arise. In **a** the brush was too dry; **b** shows the effect of holding the brush too stiffly; **c** was simply done too slowly; and **d** demonstrates what happens to the leaves if you are hesitant or turn the brush too much instead of varying the pressure.

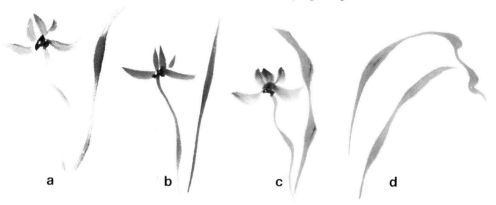

**a**      **b**      **c**      **d**

*Figure 26 Some common mistakes when painting orchids*

# *P*AINTING CHRYSANTHEMUMS

The chrysanthemum is highly valued because it is long-lasting and defies the frost by blooming in autumn. There are again two basic methods of painting it: outline and freestyle. As before, it is perfectly acceptable to combine the leaves of one method with the flowers of the other.

## Flowers: outline method

For the flower in figure 27**a**, use a plum blossom brush and dip the tip in grey ink as you did for the outlined plum flowers. Mark the centre of the flower and then draw the five petals which form the middle of the flower. Next, draw in the rest of the petals, slightly elongating them on one side of the flower and foreshortening them on the other. Take care always to have the petals growing in the right direction, i.e., straight out from the flower centre and not at an angle to it. When painting a side view (**b**), put in the sepals first and then draw the petals. The basic chrysanthemum design can have a variety of petal shapes (**c**), and a more elaborate outlined chrysanthemum is shown in figure 27**d**. The method for painting this is essentially the same. Remember, you should always strive for clear, fluid lines to your outline.

## Flowers: freestyle method

The freestyle flower in figure 28 is done with the brush fully loaded with grey ink as for freestyle plum blossom. Once again, put in the centre of the flower first. Do the petals from the tip inwards with a flicking

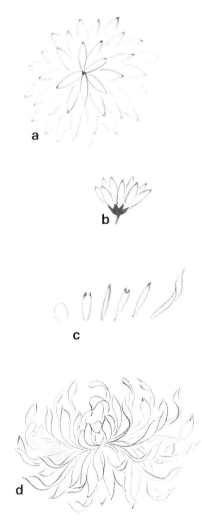

*Figure 27 Outlined chrysanthemums*

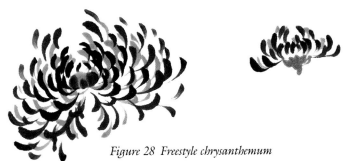

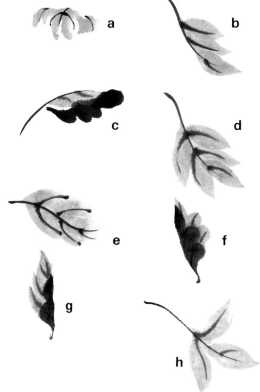

*Figure 28 Freestyle chrysanthemum*

movement like the one used for the fifth orchid petal. When you have done all the light petals, soak your brush in black and superimpose the darker petals. Take the dark petals rather further out from the centre than the light ones.

## Leaves: outline method

The outlined leaves in figure 29 should be fairly straightforward. Using only the tip of your brush, begin by putting in the centre vein with a firm stroke tapered at the end. Then outline the leaf, using a thin but vigorous line.

*Figure 30 Freestyle chrysanthemum leaves*

## Leaves: freestyle method

The freestyle leaves in figure 30 can be seen as a basic model for almost any sort of leaf you may come across. It is therefore important to practise them thoroughly so that you can tackle different sorts of leaves with confidence. Use a bamboo brush for all the leaves and always charge it fully with ink. Remember to use the whole of your brush and not just the tip. Most of the fullness of a leaf is done by placing the heel of the brush on the paper and pressing, not by filling in the shape with strokes of the tip like a watercolourist. For leaf **a**, do the central section first with a downward stroke of the side of the brush. Then add the two side sections with similar strokes but only making contact with about half of the brush. Add the veins while the ink is still wet. All the other examples here have the main vein put in first, in black, with a tapering stroke. This gives you a reference

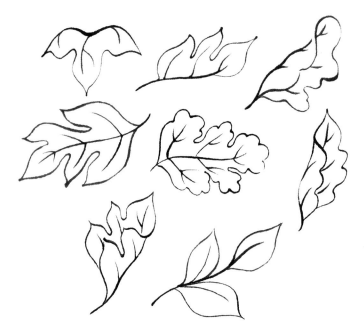

*Figure 29 Outlined chrysanthemum leaves*

point from which to build your leaf. Do not put in the subsidiary veins, however, as this will over-constrain you. For **b**, **d** and **e** put in the tip of the leaf first, then do the sections at the base, and lastly fill in the intervening ones. For **b**, **d** and **h**, work from the outside inwards to create the points; begin by putting the tip of the brush on the paper and pull the stroke down towards the vein. As you pull, lay your brush fully on the paper and press down. One stroke should suffice for each leaf section. With **e**, the sections are done outwards from the vein.

Do the same movement as before but in reverse, using the heel of your brush not only to fill out the leaf but also to provide its rounded outline. For **c**, **f** and **g**, do the rounded underside parts first, in the same way as plum petals. Finish the inside of the leaf with the method you used for **b**, **d** and **h**. With **c**, do the inside of the leaf with a twisting movement, lifting and pressing the brush as you go. Try to add the side veins to your leaves before they have dried.

## Stems

The stems of the chrysanthemums are done in the manner of plum blossom branches, but without any tapered sections.

## Using colour

Colour is applied to the outlined flower in figure 31 by using a single stroke for each

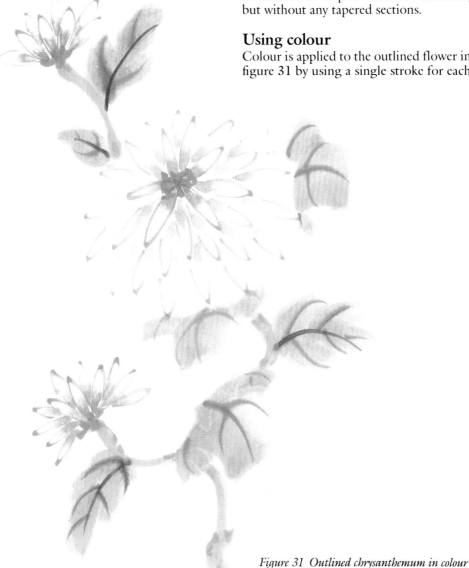

*Figure 31 Outlined chrysanthemum in colour*

petal. Soak your brush in the basic colour and wipe off any excess on the side of your palette. Tip the brush in a darker tone and then lay the brush on the petal with the tip towards its base. Push down the heel of your brush as you do this to fill in the outline. Do not worry if you do not manage to match your colour exactly to the outline.

Notice that in this illustration I have used freestyle leaves with an outlined flower. Usually these are done in grey first and then the colour is added by repeating the same strokes on top of those already done, using a watery green wash. Remember, however, that the watery colour should not be applied with a dripping wet brush. You must dry your brush before dipping it in the green, as you do after mixing the grey ink. The water is needed as a constituent of the colour rather than for its wetness.

Figure 32 shows the more elaborate kind of outlined chrysanthemum, and this time the colour is blended on both the flowers and the leaves. The blending method is fully described in the section on painting peony.

The freestyle flowers in figure 33 are simply achieved by substituting two different tones of the same colour for the ink. The leaves are done as for figure 31, but in this example no colour wash was added. Obviously you may colour your leaves and stem if you wish.

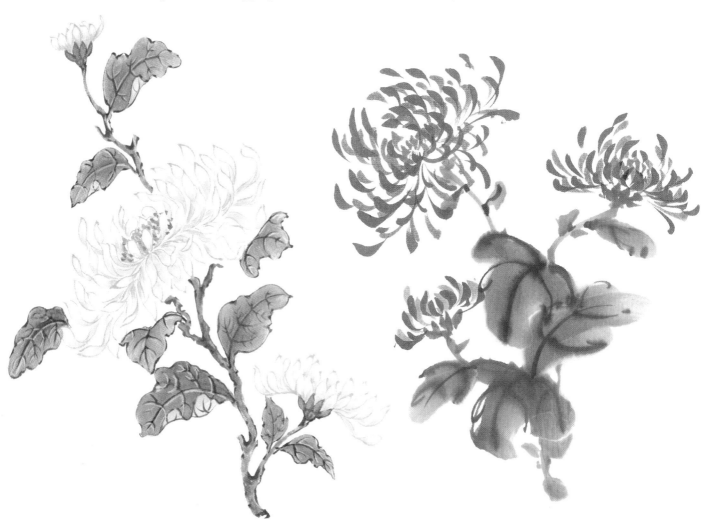

*Figure 32  Detailed outlined chrysanthemum with blended colour*

*Figure 33  Freestyle chrysanthemum in colour*

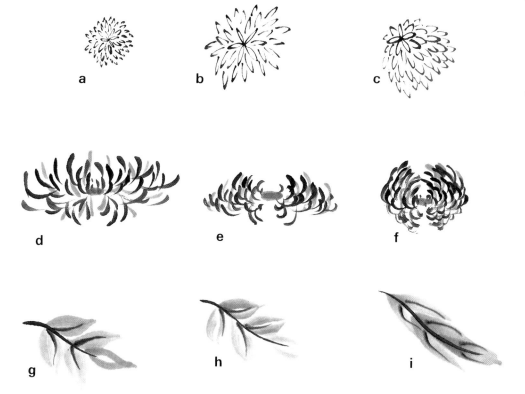

*Figure 34 Some common mistakes when painting chrysanthemums*

## Common mistakes

In addition to the usual mistakes caused by hesitancy, overworking, slowness, or ill-judged quantities of ink, colour or water, which you should be able to recognize for yourself by now, there are a few errors that are peculiar to chrysanthemums and leaves. Figure 34 gives examples: **a** is too small and cramped; **b** has petals growing in different directions, whereas they should always grow out from the centre of the flower; **c** has too many layers – create the angle of viewing by lengthening or foreshortening the petals; **d** shows a freestyle flower that has lost its centre and has stiff, lifeless petals; **e** looks as if it is growing in two clumps instead of being a rounded flower (take care to make your freestyle chrysanthemums fully rounded); **f** resembles a powder puff, extending too far vertically and not enough horizontally; the leaves in **g** were not painted with the whole of the brush – instead of being placed on the paper and 'heeled', the brush was stroked like a Western brush and only the top was used, resulting in the need for too many strokes; in **h** the same mistake has also resulted in a marked tendency for the leaf segments to gap; and in **i** the segments were done in the wrong order, resulting in the leaf becoming elongated – always do the tip of the leaf first, then, leaving what looks like too small a gap, paint the sections at the base, and lastly fill in the remaining sections. Figure 34i also has side veins that look hesitant because they were not firmly joined to the spine.

# PAINTING ROCKS

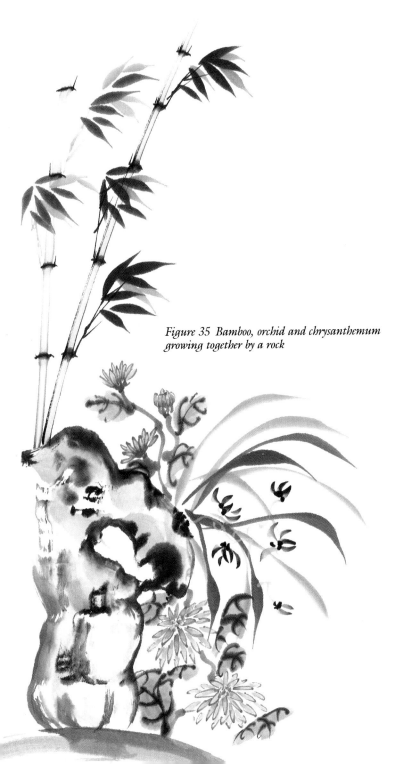

*Figure 35  Bamboo, orchid and chrysanthemum growing together by a rock*

Now that you have mastered all four of the Friends, you can try a composition that includes two or more of them. The example in figure 35 uses a rock as an additional element, and as rocks feature frequently in Chinese paintings it is useful at this stage to learn how to paint them.

In China the rock has come in a sense to symbolize the creative power of the earth itself. Westerners are sometimes bemused by the importance of rocks in Chinese art so it is perhaps helpful for us to realize that the Chinese have used rocks in their gardens rather in the same way as Europeans have used statuary. The contemplation of rocks is something the Chinese have long delighted in. Naturally, therefore, this importance of rocks in everyday life has led to their becoming an integral element of Chinese painting.

Figure 36 shows the different styles of rocks often encountered in flower and bird paintings. They are worth mastering, not only for their own sake but because you will later use essentially the same methods to paint rocks and mountains in landscapes. Think about rocks as you paint them; try to visualize the rock and feel its weight. This may sound pretentious but it is surprisingly helpful. Always put in the grey shading first and then add the black.

In figure **36a** a wet brush was used for all the strokes, which were done with the tip of the brush. Figure **36b** was also done with a wet brush, but this time the light shading and some of the black strokes were done with the side of the brush. Figure **36c** was done with a dry brush and the texture was applied using the side of it. For figure **36d**, the wash was blended to form the shape of the rock and then the black was applied

while the wash was still wet. Remember always to use as large a brush as you can manage.

Rocks can also have a colour wash, or you can use a thicker blending of colour applied in the manner described for Ling-nam lotus leaves (see page 71).

Rocks do not seem to produce any problems that are peculiar to themselves. Remember, as always, to try to visualize the finished shape before putting brush to paper. Also, try to apply each stroke with spontaneity and dash, and don't use more than are necessary.

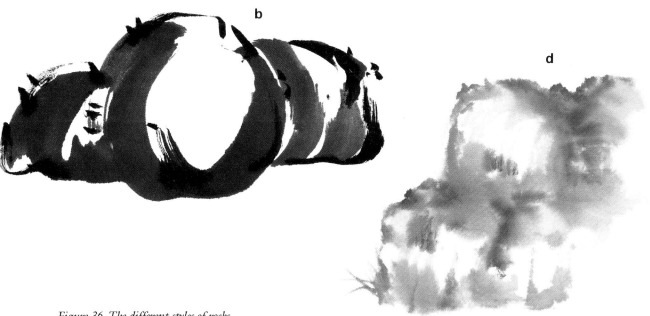

*Figure 36 The different styles of rocks*

53

# PAINTING PINE

The pine tree is a symbol of longevity – it is often depicted with cranes, which are particularly long-lived birds. Pine also stands for the constancy of friendship in adversity. It is thought of as the king of trees and this is presumably why, unlike other tree species, it has come to be studied on its own in painting courses and manuals.

There is no real methodological difference between freestyle and outline pine, except that for freestyle pine you should use a larger brush and make fewer strokes.

## Trunk, branches and roots

Begin by practising the bark as shown in figure 37. If a branch or tree trunk has a knot in it you should do this first, as you did when doing plum. Then, using a large dry brush and grey ink, do the shading by making rough circular shapes with the side of your brush. Do not make the circles too uniform and only paint enough to cover about half of the width of your branch or tree trunk. Use some semi-circles towards the centre of the trunk. Still with grey ink, draw in the side of the branch or trunk that you have not shaded, using strokes similar to those for outlining the plum branch in

*Figure 39  Pine tree roots*

figure 8. Lastly, apply the black strokes, using the tip of your brush and varied pressure.

The side branches in figure 38 are done like the freestyle plum branches in figure 5 but with even more panache so that they give the impression of being flung onto the paper. Give them an upward sweep.

For the tree roots in figure 39, fill your brush with grey ink and then dip it in black to about half-way up the bristles. Paint the hollows of the roots with a twisting motion

ABOVE LEFT: *Figure 37  Pine bark*

BELOW: *Figure 38  Pine side branches*

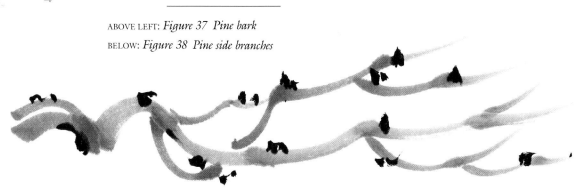

54

similar to that used for a large knot hole. Put in the root outlines with grey and black.

## Needles and cones

There are many species of pine tree and each has its own configuration of needles, but figure 40a shows the form of pine needles most usually depicted in Chinese brush painting. Once you have mastered their execution you can adapt the shape to suit your own needs. You may find it helpful at first to put in an inverted T shape and fill in the needles around it. Figure 40a has tapered needles. Figure 40b has blunt ones and fewer of them, which creates a more freestyle effect. Pine needles tend to grow upwards from a branch, but try to vary the angle slightly and overlap your groups of needles.

The pine cones in figure 41 are done in black with a flicking movement of the brush tip. Begin at the top of the cone and work back towards the base. The closer together you put the strokes the more closed the cone will look. In a painting when a pine tree forms part of a landscape and is intended to be seen from a distance the cones are often shown by means of black spots.

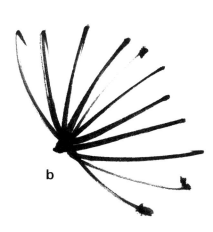

*Figure 40 Pine needles*

*Figure 41 Pine cones*

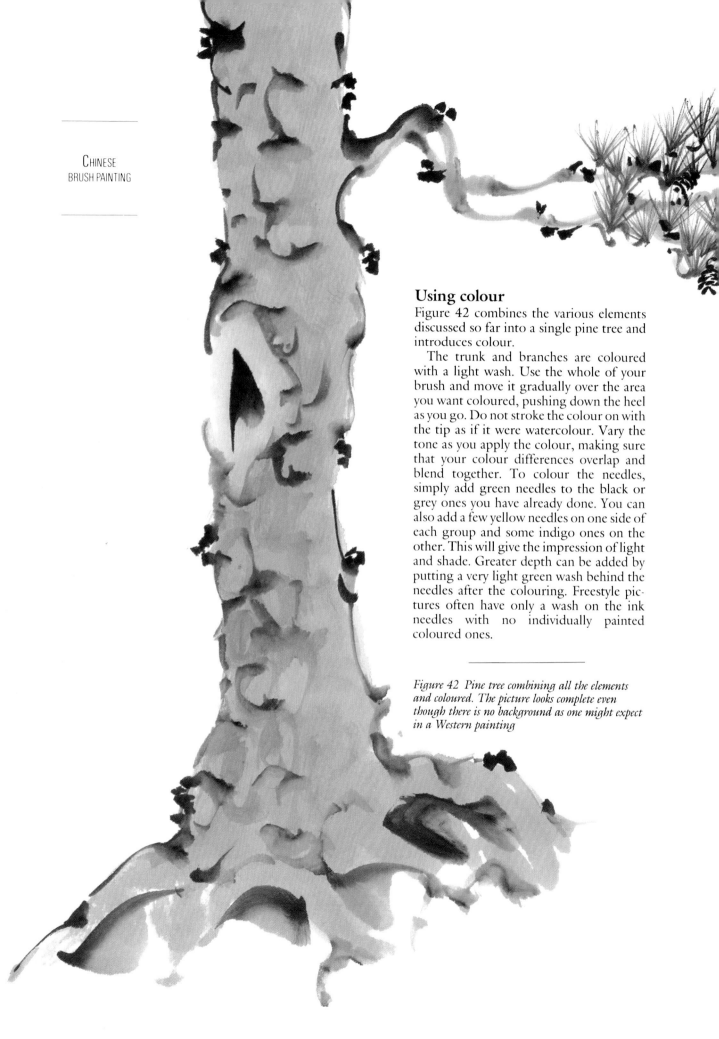

## Using colour

Figure 42 combines the various elements discussed so far into a single pine tree and introduces colour.

The trunk and branches are coloured with a light wash. Use the whole of your brush and move it gradually over the area you want coloured, pushing down the heel as you go. Do not stroke the colour on with the tip as if it were watercolour. Vary the tone as you apply the colour, making sure that your colour differences overlap and blend together. To colour the needles, simply add green needles to the black or grey ones you have already done. You can also add a few yellow needles on one side of each group and some indigo ones on the other. This will give the impression of light and shade. Greater depth can be added by putting a very light green wash behind the needles after the colouring. Freestyle pictures often have only a wash on the ink needles with no individually painted coloured ones.

*Figure 42 Pine tree combining all the elements and coloured. The picture looks complete even though there is no background as one might expect in a Western painting*

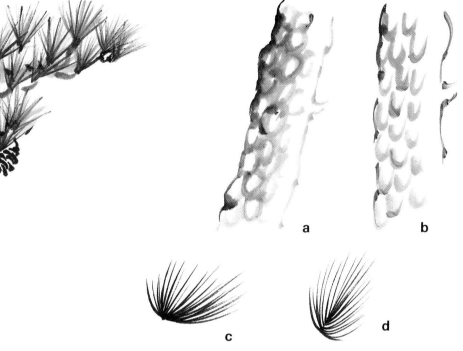

*Figure 43 Some common mistakes when painting pine*

## Common mistakes

Figure 43 shows the most common mistakes beginners make with pine. In **a** the brush was not dry enough for the shading and the circles are too neat – the brush tip was used instead of the side; in **b** there are too many semi-circles and insufficient completed ones – avoid the temptation to do little scooping strokes; in **c** the needle group is unbalanced and the individual needles are too curved; and in **d** the centre point of the needle group has drifted. Other faults which can mar a painting of a pine tree are to do with the colouring. Often the trunk looks blotchy because too little care was taken to blend the wash, and students occasionally get carried away and make the needles rather garish by adding too much yellow and indigo. I have had a few pupils who have forgotten to put the green needles in at all.

# PAINTING GRASSES

*Figure 44  Flowering grass stem in colour, showing* (inset) *how the flower head is built up*

The Mustard Seed Garden Manual of Painting[1] has a section entitled 'Book of Grasses and Insects', but closer examination reveals that it is concerned mainly with flowers such as orchid, chrysanthemum and peony. Only four pages are devoted to grasses as we understand them and even these are concerned with grasses simply as ground cover in landscapes and flower paintings. Grass is seldom the main feature of a Chinese painting but it is used so often to enhance pictures of flowers, birds and

1. *Op. cit.*

insects that I think it is useful to accord it a section on its own here.

The normal distinction between outline and freestyle methods does not have much relevance to painting grass since it is very seldom outlined. The chief difference between the grass in a *gongbi* painting and that in a *xieyi* one is that the former is more painstakingly and tidily executed. If you want to try outlining grass, draw it with a fine-pointed brush.

## Flowering grass stem

Figure 44 shows a flowering grass stem in

colour. To paint this, do the stalk first, using a yellowish green. Imagine you are painting a thin, bendy bamboo stem and you will achieve the correct effect (bamboo is after all a grass). Likewise, the leaves are done in much the same way as bamboo leaves, although they should be slightly longer and some of them should be turned by varying the brush pressure in the same way as for orchid leaves (see page 46). Use a slightly bluer green for these. For the flower head, first draw in the stems with the point of your brush. Make the seeds by pressing slightly with the tip of the brush, starting with grey seeds and adding purple or yellow ones. As a final touch you can add some white seeds, remembering that the more white you add the riper your grass will look.

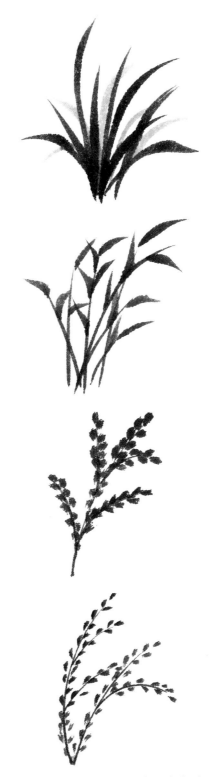

## Other grasses

The grass in figure 45 is done with a 'feather' or 'split brush' stroke. Do not have your brush too dry or you will not achieve an even stroke. 'Split' brush does not necessarily imply 'dry' brush. First do the stem rather like a thin orchid leaf (see page 46), using only the tip of your brush. Then splay out the bristles and add the feathery fronds by working outwards from the stem.

Figure 46 shows a few examples of the grass and undergrowth often used in the foreground of landscapes.

*Figure 45 'Feathered' grass stem*

*Figure 46 Grass and undergrowth of the kind frequently used in the foreground of landscapes*

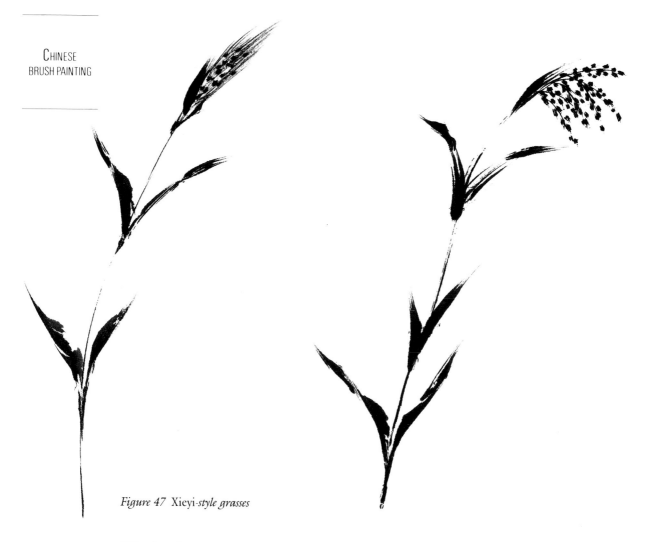

*Figure 47* Xieyi-*style grasses*

## *Xieyi*-style grasses

Figure 47 illustrates some freestyle grasses of the type which frequently occur in *xieyi* paintings of birds and animals. Ideally they should be done with a horse-hair brush (see page 22) but it is possible to do them with a dry wolf-hair brush with its tip twisted so that the end splays out slightly to give a split effect. Instead of pulling the brush to form the stem as you did for figure 44, reverse the stroke and push the brush to make the stem segments. The leaves are done in the same way as before but the effect of the horse-hair brush is to make them look unkempt. The grass heads are also done with the horse-hair brush. Naturally these *xieyi* grasses can also be done in colour.

## Common mistakes

Grass does not usually present many problems for the beginner, although some people have a tendency to be too neat, especially with freestyle examples.

# PAINTING PEONY

There are a number of flower species for which the methodology is essentially the same. Of these, the one most commonly depicted in Chinese painting is the peony, which is known to the Chinese as 'the king of flowers' and the 'flower of nobility and wealth'.

## Flowers: outline method

For the outlined flower in figure 48a, begin by deciding where the centre of your flower is and marking it in lightly. For the half-open flower in figure 48b, lightly outline the sepals in green before you put in the petals. For both examples, outline the petals, working from the centre of the flower outwards and using a darker tone of the colour you are going to paint them. It is crucial to have a clean, firm, expressive line.

There are two ways of colouring the petals. The first, as shown in figure 48a, is by blending. Always blend from light to dark: fill the petal with the lightest shade, or with white if you want a very pale flower; without rinsing your brush, tip it in a darker shade; place the brush so that the tip comes where you want the darkest tone to be (usually the base of the petal or round the edge) and press down, running the darker colour over the light one; rinse and dry the brush and blend the tones together with a clean brush. If your colour is not dark enough it is permissible to add more and reblend, but you should be careful not to overwork and make the paint too thick or scuff the paper.

Always finish one petal before going on to the next; you may save time by applying all the light colour first and then going round again with the darker shade, but the effect will be somewhat stripey because the light tones will dry before you can add the dark ones. Relax and take your time; colour blending is a very soothing occupation. Hopefully your colour will not run outside your petal shapes, but do not worry too

a          b

*Figure 48 Outlined peony flowers*

61

much if it does. Simply wash over the edges of the run with clean water to avoid a water-mark (this may make it run further but do not panic) and when you later put a wash on your painting, use a tone that will blend with the colour so that you finish up with a darker-toned halo to your flower. You may also be able to avoid the problem of colour running to some extent by adding more white to your darker tones.

The second method of colouring peonies is illustrated in figure **48b**. It gives a more delicate effect but is not suitable if you are intending to add a wash to your picture because the petals will pick up the back-ground colour. Fill your brush with water and put just the tip in some fairly dilute

colour. Then place the tip of your brush at the base of the petal and press down with the heel of the brush, trying to fill the petal with one movement. It is not very practical to use this method for flowers which are darker at the outside edges since it is almost impossible to stop the wetness flooding over the edges. This does not matter, however, if your colour is concentrated in the centre of the flower because it will only be water that runs outside the outline.

Whichever method of colouring you use, you should add the stamens in white or yellow.

## Flowers: freestyle method

For the freestyle peony in figure 49, take a large brush (bamboo size or bigger) and saturate it with the lightest shade. Next, dip

*Figure 49  Freestyle peony*

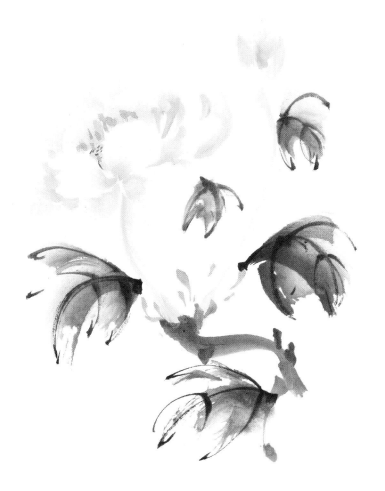

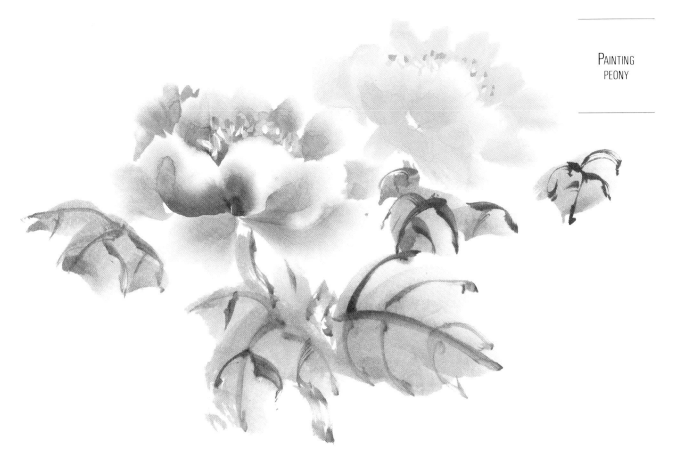

*Figure 50 Freestyle peony with water substituted for the lightest tone*

the brush about half-way up the bristles into a darker shade, then dip the very end of the brush into still darker colour. Decide where the centre of your flower is and place the tip of your brush at this point. Press down the heel of the brush, moving the base sideways while keeping the tip still, then lift the brush cleanly off the paper. Do the other petals in the same way, remembering that you would not be able to see the bases of all the petals and adjusting the colours on your brush accordingly. Add the stamens with thick gouache white and tip them in yellow, orange and red at random. For the side view, remember to put the sepals in before the petals, as with the outline peony. Sometimes it is permissible to blend in a little colour onto the edges of the petals as well, to give your flower more shape.

If you want to reverse the colour sequence of your petals by having the darkest tones on the outer edges of the petals, you can do this in two ways. You can either simply fill your brush with light colour, very carefully dipping just the heel into a darker colour, and then use the same method as before; or you can load the brush as previously described, but reverse the technique. This means that you should place the brush on the paper with the heel towards the middle of the flower, then swing the darkened tip of the brush round to form the outside edge of the petal.

The two-tone effect in freestyle flowers can also be achieved without using two or three colours. Wash your brush in clear water and dip about half the bristles into watery colour. Tip the end of the brush in concentrated colour and use the brush as you did before, pressing down the heel and moving it gently sideways. Figure 50 gives an example of this method.

*Figure 51 Outlined peony leaf with the colour applied by blending*

## Leaves: outline method

The outlined leaf in figure 51 is done by first drawing the veins in very light green and then equally lightly marking in the outline. The colour is applied by blending in the same way as for the petals, starting by bringing a brownish tone in from the outer edges and running fresher green out from the centre. Use a fairly dry brush and have your colour mixture quite rich so that you can leave the veins with an unpainted line alongside them. If your colour runs so that you lose the white veins, or if you prefer not to try to leave a gap for them, you can draw them on when the colour is dry, using opaque light green. Outline the leaf with very dark green or brown, using a lively line with varied pressure, and enhance the veins by putting in a dark line on one side of the white or green vein (following your original faint line). This time use a smooth stroke tapering at the tip. Vary the shape and style of your leaves depending on the species of flower you are painting.

## Leaves: freestyle method

The freestyle leaves are done in the same way as the chrysanthemum leaves in figure 30b, **d** and **e**, taking account of their different shapes. In other words, put in the centre vein and build the leaf around it by doing the top section first, followed by the base sections. Lastly, fill in the intermediate segments and the side veins. Use a large soft brush for the leaves.

## Other flowers

When you have practised a few peonies, try a magnolia (figure 52), using the outline method; the technique is essentially the same. Do the stems and leaves freestyle first

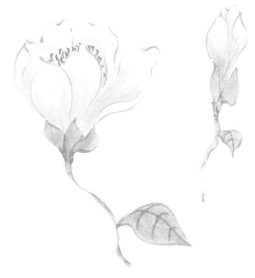

*Figure 52 Magnolia by the outlined and blended method*

*Figure 53 Usually flowers are painted before leaves, but in the case of this begonia the leaves should be done first because they dominate the picture. The veins are drawn in white before the colour is added to the leaves. Again the composition is very simple*

and then outline them. Similarly, try some of the other freestyle flowers, as illustrated in figures 53–5. Once you have mastered the technique of painting peony there is no reason why you should not attempt any kind of flower you wish to paint in either the outline or the freestyle method.

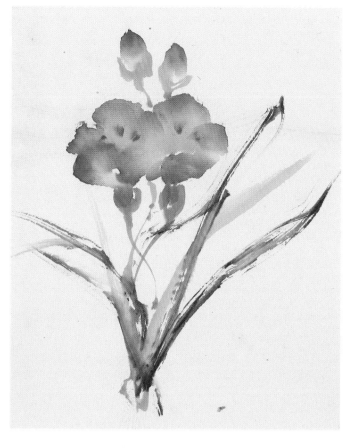

*Figure 54 The method for painting this rose is very like that for the freestyle peony, but highlights are added with strokes of colour and white while the petals are wet. The bud should be outlined before the colour is filled in*

*Figure 55 This lily is painted with a large soft brush loaded with water and tipped with dilute colour. The petals are painted in much the same way as plum blossom petals, although on a larger scale, and then the funnel-shaped flower bases, stalks and leaves are added*

## Common mistakes

The commonest faults found in *gongbi* flower paintings are inadequate blending and poor shape. Always blend carefully and do not have your colour too watery or it will flood out of your petals. This will also happen if you forget to blend from light to dark. The effect of adding white to a water-based colour is to cause the colour to run out. In any case, your colours will not blend properly unless you work from light to dark. Do not have your white too thick or your flowers will look heavy. As to shape,

keep the whole flower in mind as you draw each petal so that you maintain a balance. Make your outline strokes clean and lively.

For the freestyle flowers, load your brush carefully and remember to use as few strokes as possible, making each one tell. Use the whole of your brush. Faults that crop up regularly are usually the result of overworking with too little of the brush, or of too diluted colour. The leaves present problems similar to those described in the section on chrysanthemums (see page 51).

# PAINTING LOTUS

Although it is another large-petalled flower, the lotus merits a section of its own. It is an important theme in Chinese painting and its leaves are unlike any we have dealt with so far. In addition, there is a way of painting lotus, originated by the Lingnam school, that is quite different from anything you have tackled before, while being firmly rooted in the traditions of brush painting.

The lotus is a symbol of summer and fruitfulness. It represents purity and perfection. The flowers are normally either white or pink and the leaves are dark bluish green on top and light green underneath. The edges of the leaves start to turn brown almost as soon as they reach full size.

## *Gongbi*-style lotus

The outlined lotus flower in figure 56 is done in the same way as you did the peony (see page 61). Lightly outline the seed pod and then draw in the petals using a fine-pointed brush. For coloured flowers it is effective to outline the petals in red and then blend the colours as you did before. Run a very weak yellow wash over the inner surfaces of the petals after you have blended the pink. These inner surfaces should be very pale; the outer surfaces can be quite deep pink. You can add fine veins to the petals by using a feather stroke and red paint. Blend light and dark green for the seed pod, adding a tinge of red to your brush tip. Put in the black seed holes with gouache yellow centres. If you have no gouache yellow, mix your Chinese or Japanese yellow with gouache white to achieve the desired opacity. The stamens are also done in opaque yellow and the pollen in yellow, orange and red.

Draw the leaves in very light green. You will probably find it easiest to achieve a pleasing shape if you first mark in the centre and the veins lightly and then work the outline around these. Note that some lotus veins are forked at the end and some are not. When you have established the shape, damp the leaf all over with clean water. Shade the darker areas of the upper side of the leaf with ink, taking care to blend from nearly black to almost clear without sudden changes of density. Apply the ink as you did the wash to the plum blossom branch, by pressing down with the heel of your brush while gently moving the tip. When the paper has dried, add the colour to the leaf, blending it as you work. Use fairly thick colour and once again move the brush very gradually over the leaf area, pressing down with the heel as you go. Blend in brown, orange, yellow and even some white at the edge and round any holes you have in your leaf. Before the colour is quite dry, re-outline the leaf in greenish black, using an uneven pressure on the point of the brush. Add the veins and the centre last of all, using very light green mixed with gouache white to make it opaque. Pick out one side of each vein with the colour you used for outlining the leaf. The underside of a lotus leaf has no ink shading, but the colour is blended as for the upper side. Use a light yellowish green as your predominant colour. The veins on the underside should be darker than those on the upper surface.

The stalks of the leaves and the flowers are the same. Using a plum blossom brush,

*Figure 56* Gongbi *lotus, using blended colour for the flowers. An ink wash is applied on the top of the leaves before the colour is blended in*

66

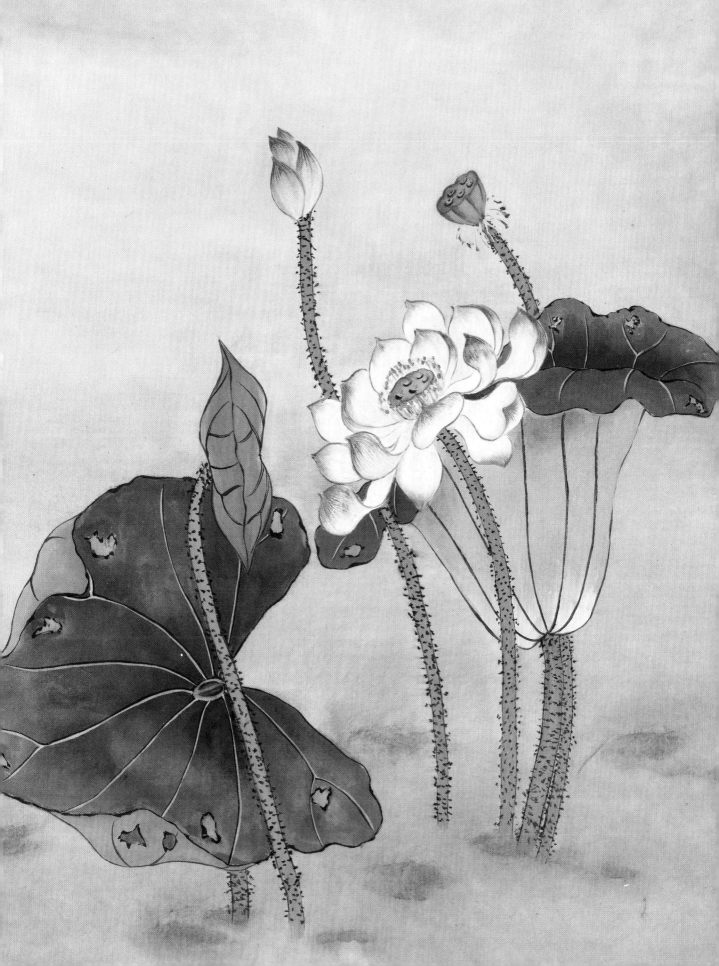

fill the bristles with brownish green and dip the sides in a dark reddish tone as you might for a bamboo stem. Begin painting the stalk at the flower or leaf and work downwards. Add the black dots for the hairs on the stalk immediately before it has time to dry. To learn how to complete your picture, turn to the wash section on page 115.

## *Xieyi*-style lotus

The flower in figure 57 is also outlined, but in the *xieyi* style, using a horse-hair brush to make vigorous strokes. You can do this in grey, black or red. Often this style of flower is found in an ink painting, but if you want to add colour to the petals you should use the watery method described in the section on peonies (see page 62). However, there is

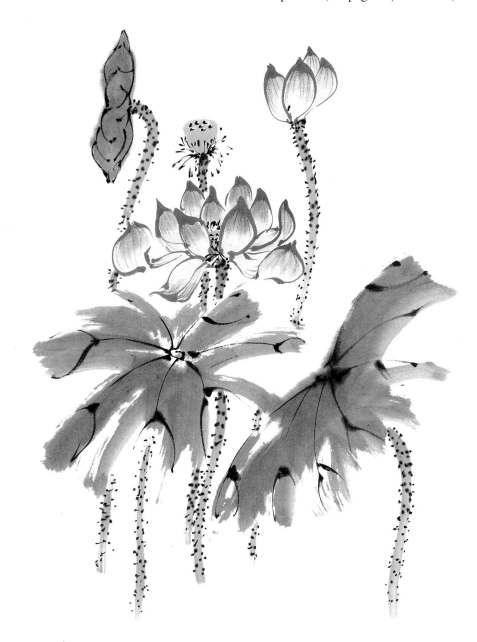

*Figure 57* Xieyi *lotus with outlined flowers*

a slight difference in technique as you should have two focuses of colour – pink at the top of the petal and yellow at its base. To do this, fill a large brush with water and dip the end in dilute red. Place the brush inside the petal outline with the tip towards the top edge. Press down the heel of the brush to spread the water. Then wash your brush and tip it in very dilute yellow. Repeat the process, this time placing the tip of your brush at the base of the petal and making sure that when you press down with the heel of the brush the moisture spreads into that left by the earlier stroke. The stamens are done in black, yellow or red, depending on the general colour scheme of your picture, and the pollen should be the same colour as the stamens.

The leaves are usually done in grey with black veins even if the flower is outlined in red. Use a very large brush, preferably a soft white one if you have it, and soak it with dark grey ink. Work the shape of the leaf from the inside outwards, using as few strokes as possible and pressing down the heel firmly to make the outside edge of the leaf. While the leaf is still wet, add the veins, using a dry brush and very black ink. Remember to vary the forked veins with the unforked ones, as in the previous example. The stalks are also done in grey with black splodges.

Figure 58 shows a *xieyi* lotus done by the non-outline method. The centre of the flower, the seed pod, is painted with a single pressed-down stroke, using a large brush loaded with yellow. The black seed holes are added on top. The petals are done like freestyle peony petals, but remember that lotus petals tend to be darker at the top so this is where you should place the tip of your brush, pressing down the heel to make the lighter base of the petal. Use a clean brush loaded with water and tipped in red for a translucent effect, but for a more substantial flower, load your brush in pink or yellow made with white paint and tip in red. The stamens should be white with yellow pollen or yellow with orange and red pollen, or you can do them in black, as in this example.

The leaves and stalk are done in the same way as for figure 57 but you can add a green wash on top.

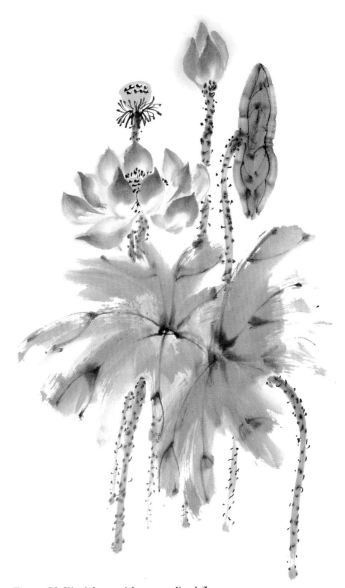

*Figure 58* Xieyi *lotus with non-outlined flowers*

## Lingnam-style lotus

Figure 59 is done quite differently from the previous three examples and the wash is an integral part of the picture. The other lotus styles can be enhanced by a wash, but in this case it is essential and you will therefore need to consult the section on washes (see page 115). In order to make life a little simpler for yourself, I suggest that you sketch the outline of the leaves lightly in charcoal. It is a feature of this method that everything runs and if you have marked

69

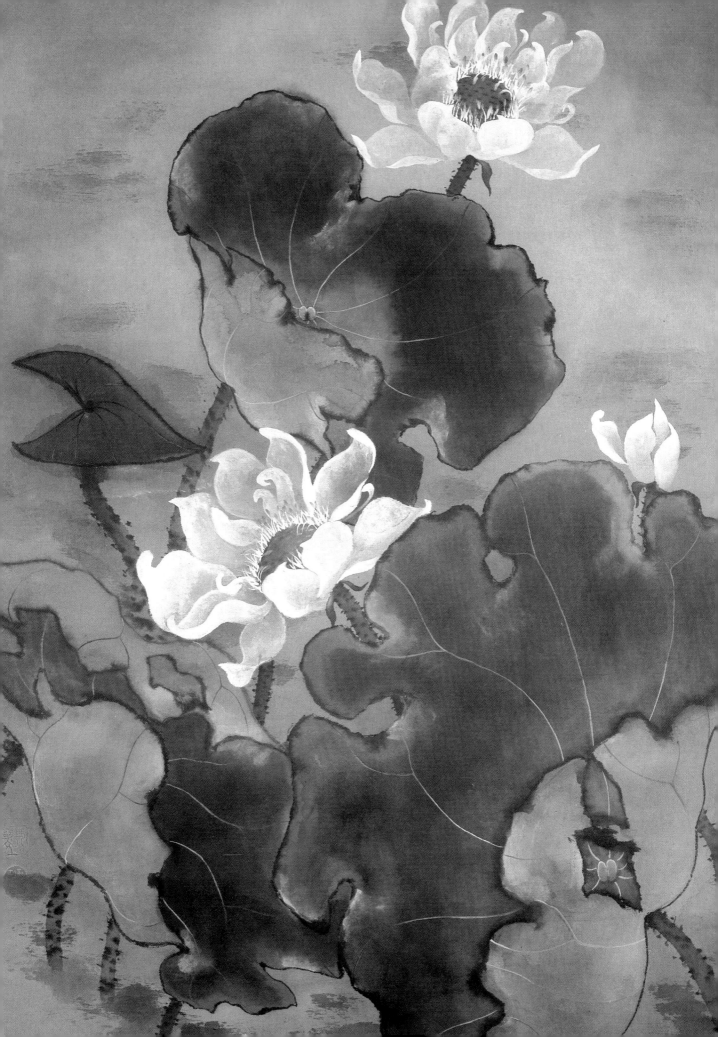

your leaf edges in ink they will probably finish in the wrong place. Rub off the excess charcoal and shade the leaves as you did for figure 56. This time, however, the colour is added on top of the ink shading while the ink is still wet. Blend the colour in the same way and do not worry if it spreads because of the wetness of the paper. Make the edges of the leaves and the surrounds of the holes nicely tatty with plenty of brown, orange, yellow and white blended in. As before, the undersides have no ink shading and are predominantly light green. Allow the leaves to dry partially. When they are just damp and have completely stopped spreading, add the outline of the leaf using a horse-hair or twisted wolf-hair brush and black ink, and remembering to leave gaps in the outline where your flowers are going to be. Lastly, add the veins as you did in figure 56.

The stalks, which are the same as for figure 57 but are done in colour, should be painted next. Make sure you put in stalks for the flowers even though you have not done these yet.

Allow the painting to dry and then add a wash, blending blues, greens and browns as described in the section on washes. Use a fair amount of colour so that the places where your leaf colour has spread blend into the background. When the wash is almost dry, add a few lily pads by filling a large soft brush with dark green tipped with brown and pressing down sideways on the paper.

Once the wash has completely dried you can add the flowers. This is one of the very few occasions when you add anything to a picture after the wash is done. Put in the flower centre (the seed pod), using a large brush loaded with bluish green and tipped with dark red. Charge a large soft brush with very diluted gouache white and tip it in concentrated white. Then do the petals as you would normally for a freestyle flower. Remember, when deciding on the thickness of your paint, that white is more opaque when dry than wet. Add a few dense

white small petals round the seed pod and some thick white undersides of petals and turned-in edges. Run a very thin yellow wash over the inner surfaces of the petals. Make sure each flower joins the stalk you have painted for it. Finally, do the stamens in very thick white and the pollen in yellow, orange and red, then add the sepals.

## Common mistakes
Lotus flowers present much the same sort of problems as peonies and other large-petalled flowers. Take particular care when painting the white flowers in figure 59 to get the correct variation in density of white. The commonest mistake with all styles of lotus leaf is patchy colour. To avoid this, take time when blending and press down firmly with the heel of your brush while moving it very gradually over the leaf area.

*Figure 59* The Lotus Pond. *Painted in the Lingnam style, this picture is an example of one of the few instances when anything is added to a painting after the wash has been done – in this case the white flowers* (private collection)

# PAINTING INSECTS

With the possible exception of horses and birds, the Chinese have traditionally placed a low value on paintings of fauna. They have considered flora, particularly bamboo, and above all landscape to be more worthwhile subjects for artists. Indeed, *The Mustard Seed Garden Manual of Painting* relegates insects to the last few pages of its 'Book of Grasses and Insects', and heads each of these pages with the words 'Examples of insects for paintings of grasses and herbaceous plants'. In other words, the plant is intended to be the main subject – the insect is there merely to enhance it. Japanese painters have on the whole paid more attention to insects and have given them a more prominent place in compositions. The Lingnam school, however, has fully exploited the potential of insects.

## Outline method
Figures 60 and 61 show outline-method insects, the kind used in pictures of large-petalled flowers done in the *gongbi* style.

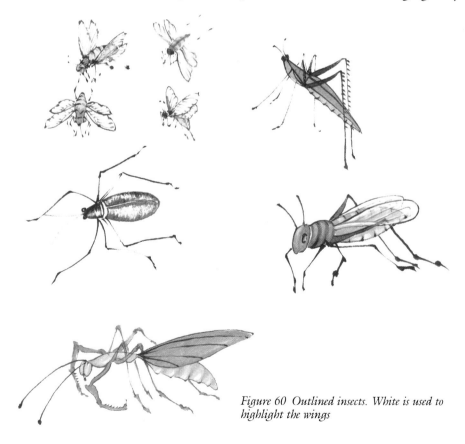

*Figure 60 Outlined insects. White is used to highlight the wings*

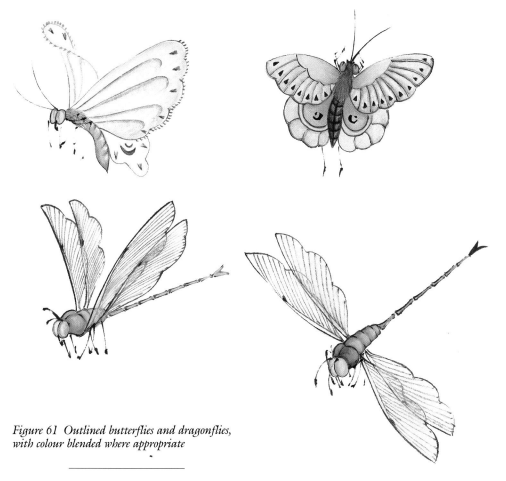

*Figure 61 Outlined butterflies and dragonflies, with colour blended where appropriate*

Draw the outline with a fine-pointed brush and then fill in colours according to desire or to the laws of nature. Blend where it is appropriate to do so – for example, on butterfly wings. You can achieve a gossamer effect for transparent insect wings by using a very delicate touch on the veins and slightly emphasizing these at the joins. Use only a very dilute off-white wash for the wings; just enough so that when the picture is washed, the wing will be very delicately differentiated from the background colour. If you can get hold of some Chinese gold paint, you can use this to enhance butterfly wings.

## Freestyle method

While outline insects are relatively straightforward to paint, freestyle insects can cause problems because they must be done with the minimum of strokes and the maximum of panache. For the bees in figure 62, put in

the head, eyes and stripes first. Fill your brush with yellow and tip it in a mixture of burnt sienna and vermilion. Lay the brush over the back stripe with the tip towards the head. Press down lightly and immediately lift the brush cleanly off the paper. Then add the legs and antennae. Feather your brush and put in the wing veins, remembering that the front pair of wings is larger than the rear pair. To paint the wings, fill your brush with very dilute white and press

*Figure 62 Freestyle bees*

73

down once for each wing with the tip towards the body.

For the dragonfly in figure 63, begin by putting in the head with a firm 'bone' stroke. Preferably you should use a horsehair brush or, failing that, a plum blossom brush. Next, do the neck and thorax without taking the brush off the paper. Continue straight on to the body, which is done with a stop/start stroke similar to that for a small freestyle bamboo stem. Taper the last segment. Add the legs with light but very firm strokes, going back slightly on yourself at the joints. Remember that most insects have six legs and that one pair is often more prominent than the others. Add the antennae. Paint the wings with a dry brush and very light ink, starting at the

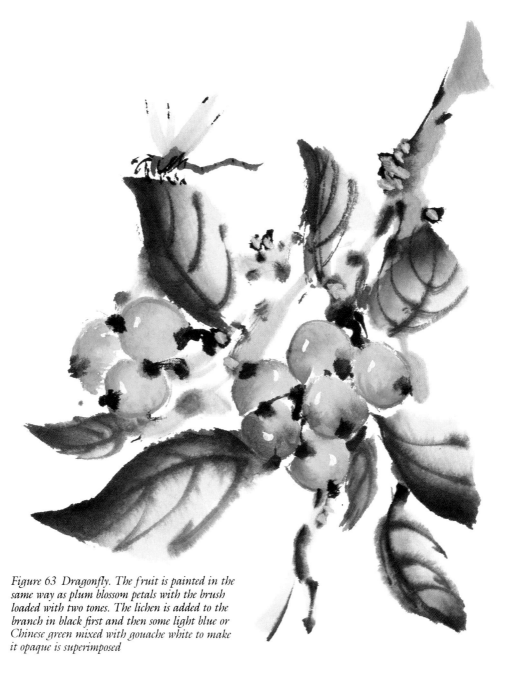

*Figure 63 Dragonfly. The fruit is painted in the same way as plum blossom petals with the brush loaded with two tones. The lichen is added to the branch in black first and then some light blue or Chinese green mixed with gouache white to make it opaque is superimposed*

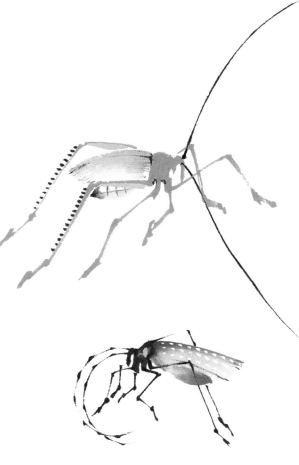

as called for by the species of your beetle. The antennae on the lower beetle are done with a stroke similar to that for the dragonfly's body.

The principles of painting the praying mantis in figure 65 are essentially the same, but change the shape of the thorax and angle the wing more sharply than for the beetles. Make the antennae especially long and try to make them look as if they are waving about. Notice the shapes of the legs: the front ones should be a substantial feature since it is from these that the creature gets its name.

*Figure 65* Praying Mantis. *Space is again used as a compositional element here*

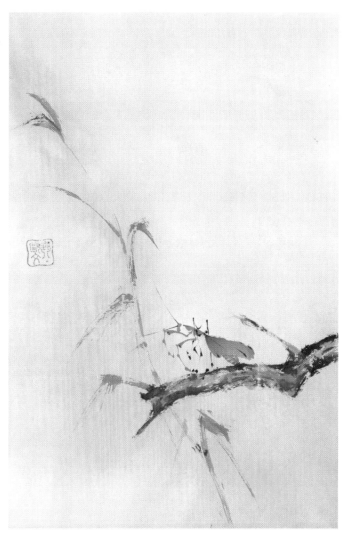

*Figure 64  Beetles*

body and pulling the brush upwards and sideways to achieve the ragged edge. Lastly, add the small black marks at the tips of the wings.

The head and thorax of the beetles in figure 64 are done like the dragonfly's. For the wing section, fill your brush with the required colour, dipping half the length of the bristles in a slightly darker tone. Position your brush on the paper with the tip against the top of the thorax and the heel at a slight angle to the right. Press down lightly while simultaneously pulling the brush sideways, then lift it as you do the stroke until the brush has left the paper. Next, fill your brush with the two tones you are using for the body and lay it on the paper with the tip towards the tail. Press down the heel and immediately lift the brush cleanly off the paper. Add the legs, making sure they all come from the thorax and adding black hairs or thickening them

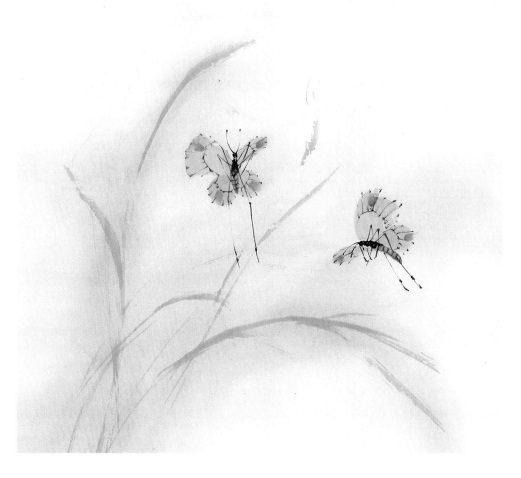

*Figure 66* Butterflies. *All the wings are completed without taking the brush off the paper*

The butterflies in figure 66 are slightly different because you do not start with the head but with the wings. Fill a plum blossom brush with a light colour and tip it with a darker tone. Place the full length of the brush at the outside edge of the largest wing, then, keeping the whole of the brush in contact with the paper, pull the brush towards where the body will be. Without taking the brush off the paper, draw it backwards along the bristles and make a circle for the second wing, using a stroke similar to that you would use for a plum blossom petal. Still without taking the brush off the paper, pull the tip across and make another smaller circular wing, then

*Figure 67 Caterpillar spinning a cocoon*

draw the brush up and out to make the fourth wing. At the last moment, press down lightly with the heel of your brush and then lift it off cleanly. While the wings are still wet, add the two-tone splodges. The head and thorax are painted in black and the body in an appropriate colour. Paint in the legs and antennae and put veins on the wings, remembering to emphasize lightly the points where the veins meet.

Figure 67 shows a caterpillar or silk-worm spinning a cocoon. The basic shape of the body is painted in light tone with a single, twisting motion of the brush. While this is still wet, pull the feathered strokes out with a split brush, then add the darker area and feather it. Indicate the head with slightly darker tone and, using black, put in the feelers and the stripey markings. Touch the ends of a few spines with dark colour as you did for the joins on the butterfly's

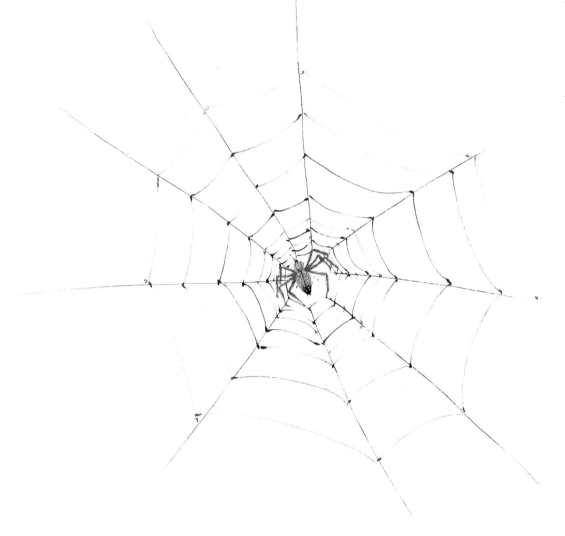

*Figure 68 Spider*

wing markings. Lastly, add the white spots.

Although they are not strictly insects, it seems appropriate to include spiders in this section (figure 68). Do the head first, followed by the thorax and the body. The legs are painted with firm strokes which are then feathered. Lastly, add the feelers. If you put your spider on a web, you must make the web look as if it could support the spider's weight, so keep the strands straight. Emphasize the joins in the same way as you do when putting veins on an insect's wing.

## Common mistakes

By far the most common difficulties in painting insects are caused by a lack of understanding of their shapes and proportions. Students often elongate the bodies, make the heads too small, or put them too near the thorax. They also have a tendency to make wings too small and legs insubstantial and hesitant, so be careful when painting these. Make sure, too, that you join the legs and wings in the right places. Another common failing is to have the colour too thin. It's important to use fairly thick paint and a dryish brush, otherwise your insect will look insubstantial rather than delicate. Study insects closely; you may be surprised to discover that even spiders are fascinating at close quarters!

# PAINTING FISH AND OTHER AQUATIC CREATURES

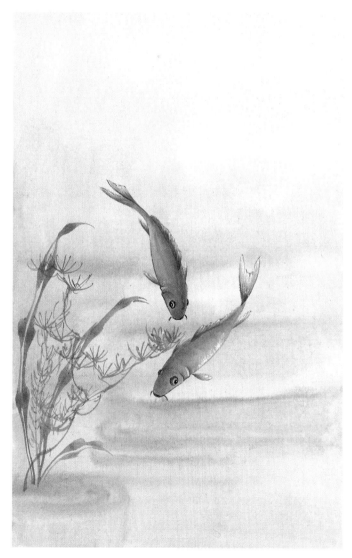

Although less common in Chinese painting than birds, fish have been a constant theme. They are often thought to represent abundance and the regeneration of life, and a pair of fish can symbolize sexual union.

### *Gongbi*-style fish

For the fish in figure 69, outline the shape lightly in grey ink, starting at the head and putting in only the main line for each of the fins. Then clean your brush and put a stripe of water down the length of the body, taking care to cover only about the centre third. Fill your brush with light grey ink, remembering to wipe off any excess on the side of the palette, and tip it with black ink. Placing the brush so that the darkest ink comes along the spine of your fish and the lighter tone in the heel of the brush runs into the damped area, run the colour into the outline, beginning at the head but avoiding the eyes. Wash your brush thoroughly and then fill it with dilute gouache white, tipping the end in concentrated white. This time, position the brush so that the tip runs along the belly of your fish and the dilute white on the heel runs into the damped area. Rinse your brush and blend the two colours together.

You will need to do the gills separately, though the method is the same. The fins and the tail are also done in a similar way but without any preliminary wetting of the

*Figure 69* Fish. *For these* gongbi *fish colour is blended from dark to light – the only occasion this happens*

paper. For the fins, put the darkest colour along your guide lines; for the tail, put it at the base where the tail joins the body. Finally, paint in the eyes and their surrounds, and add a few white and black markings to the fins and tail.

You will have noticed that the normal rules about blending from light to dark are reversed for fish – the only occasion this happens. This is because the dilute white over the grey gives a silvery effect highly to be desired when trying to suggest fish scales under water. The chapter on washes (see page 115) explains how to achieve the water effect. For the frondy weeds, use a stroke similar to that used for pine needles. It goes without saying that you can substitute a colour for grey when doing this kind of fish.

The fish in figure 70 are done by the same method, but before you add the shading or colour you should draw more detail and put in the scales. In figure 70a do this with just a fine line, but in figure 70b you should also add some grey shading and black spots for the breathing line down the side of the fish. Obviously fish vary widely in colour and shape but the same basic method described here applies in most cases.

## *Xieyi*-style fish

Two styles of freestyle fish are illustrated in figures 71 and 72. Figure 71 shows Lingnam-style fish, which are begun by drawing the front of the mouth and the eye bulges in black. Add the gills in grey and then, using very light ink, mark in the backbone. Still using light ink, put in the line of the belly by positioning the tip of your brush at the point where the gill turns upwards and pulling it back along the line of the belly. Keeping the angle of the

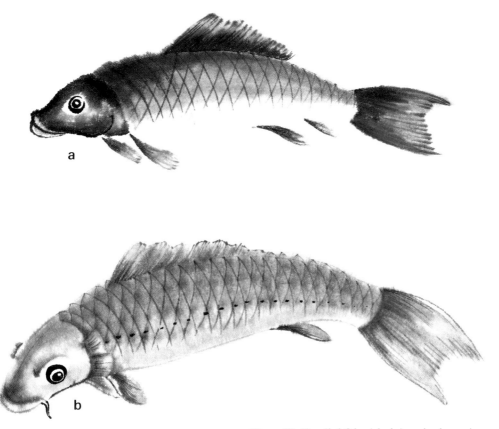

*Figure 70 Detailed fish with their scales drawn in lightly before the shading or colour is added*

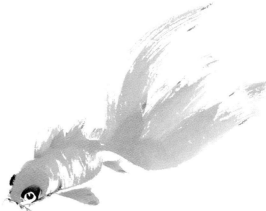

*Figure 72  Freestyle goldfish without an outline*

bristles the same, make the upward stroke at the back of the belly with the side of the brush. Still without taking the brush off the paper or altering its angle, follow the line round to make the lower edge of the tail, tapering the stroke. Then add the other side of the tail. Mark the fins as you did for figure 69.

Next, wet the centre of the body area. Paint in the dark colours on the body using rich, bright colour on the tip of your brush and pressing down with the more dilute colour in the heel so that the colours blend with each other and run slightly into the dampened central area. The colours are usually variegated: orange, yellow and red; or brown, red and black. The lighter portions of the head and body are done with white, using it thicker on the belly as for figure 69. Highlight the gills with white and the eye bulges with sky blue.

The side fins are done by loading the brush with varying tones and stroking on each fin with one stroke, starting with the brush tip against the body and pulling outwards. The dorsal (back) fin is done by loading the brush with the same tones and positioning it sideways along the backbone with the tip towards the head. Pull the brush upwards with a sideways stroke, at first keeping the whole brush in contact with the paper but then, as you move upwards, gradually lifting it off, starting with the heel. For the tail, once again load your brush with the same tones and use a side stroke, but this time do it in reverse: begin with only the tip of the brush in contact with the paper at the point where

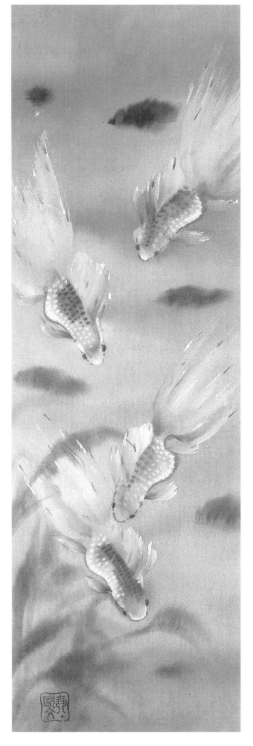

*Figure 71* Goldfish. *Lingnam-style goldfish, with reeds added while the wash is still wet* (private collection)

the tail joins the body and gradually press down the heel as you move the brush outwards, keeping the bristles at right angles to the direction of your movement. Once you are using the full length of the bristles, start to lift the brush off the paper, continuing the stroke into the air. Two strokes like this should be enough to complete the tail. Lastly, add the splodges of colour on the fins and tail, and some light veining in colour and white, together with the scale dots.

In contrast, the fish in figure 72 is done without an outline, using a method which can be very effectively adapted to different shapes (see figure 73). Begin by putting in the eye and its surround, then add the mouth and the gills. Load your brush with light ink and half fill it with dark ink. To fill in the body, place the brush so that the tip

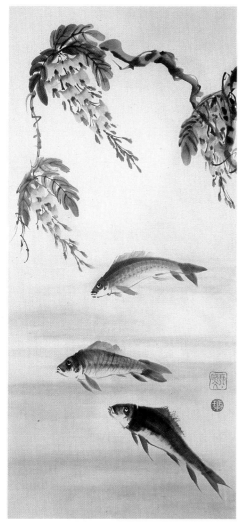

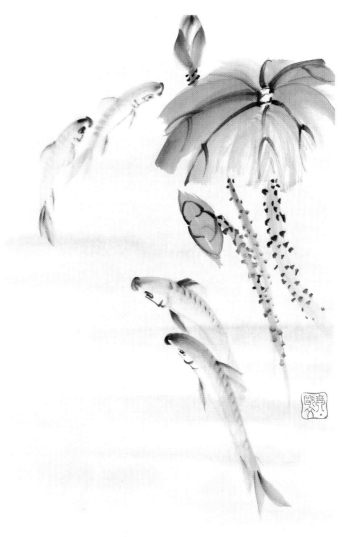

*Figure 73* Fish with Wisteria. *The scale markings are added to the fish while it is still wet by putting in fine criss-cross lines and dabbing a hint of shading into the scales. The flowers of the wisteria are done first, using a suitably loaded brush and painting the main petals with an inward, sideways stroke. Then the darker, smaller petals and the stalks are added. The central veins for the leaves are put in next, using the shape of the brush pressed onto the paper to form the leaf sections. The other veins are added and lastly the branch and tendrils put in*

*Figure 74* Fish and Lotus. *This is painted on wet paper. The illusion of water is created by the use of space*

is pointing towards the top of the head and the bristles are lying along the backbone, and start to pull it back to the tail, almost immediately stroking it downwards in a rounded movement to shape the flank. Add a light dry line to suggest the belly. Paint the tail and fins as you did for figure 71, although without first putting in a guide line.

In figure 74 wet paper was used so that the bodies of the fish blended into the background. In this case, you should paint the head first, followed by the body, fins and tail. Add the eyes and gills last. Remember to load the brush from light to dark as before, but this time create the body of the fish by pulling your brush along its bristles rather than across them.

## Other aquatic creatures

While we are on the subject of fish, it seems logical to deal with other aquatic creatures which have become increasingly popular with contemporary Chinese painters.

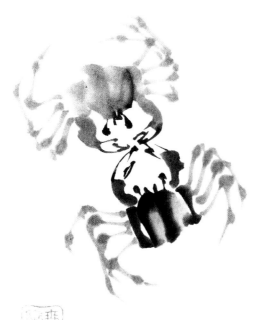

*Figure 75* Crabs. *This picture is done in the style of Qi Baishi, perhaps the best-known twentieth-century Chinese painter. Once again a simple subject painted with the minimum of brush strokes nevertheless makes a satisfyingly complete composition*

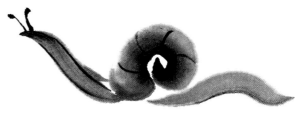

*Figure 76 Snail*

To paint the crabs in figure 75, fill your brush with light grey and tip it in dark ink. Paint the central section of the shell with a downward stroke using the side of the brush; the side segments are added in the same way. Then put in the pincers and the eyes. Lastly, add the legs, using a bamboo stem stroke but tapering the feet sections.

For the prawns illustrated on page 134, begin with the head by doing two strokes with the brush tip towards the head and the heel pressed down. Next, put in the body segments and the tail, then add the eyes, mouth, tentacles, legs and pincers.

For the turtle illustrated on page 10, put in the light shading for the shell first and then the shading for the head (remember your technique for branches and rocks). While the grey ink is still wet, add the shell markings and the legs in a darker tone, and lastly pick out the face in black.

Figure 76 shows a snail, which is not normally regarded as an aquatic animal but which seems to fit most readily into this section. Do the shell first, in a light tone, beginning in the middle and gradually increasing brush contact as you progress. Add the head and body, and then put in the markings and the eye stalks. If you want, you can also include a trail mark by damping the paper and putting in a faint line where the snail has been. Do this after you have applied a wash and while the picture is still wet.

The frog in figure 77 will probably cause you more trouble than the crab and the prawns. Put in the eye first. Then load your brush with a base of dirty green and a tip of dark red. Place the tip of the brush to make the mouth and press down for the head, moving the heel slightly to make the eye bulge. Without taking the brush off the paper, lift the heel as you pull the brush backwards to make the neck. Still with the brush on the paper, press down firmly

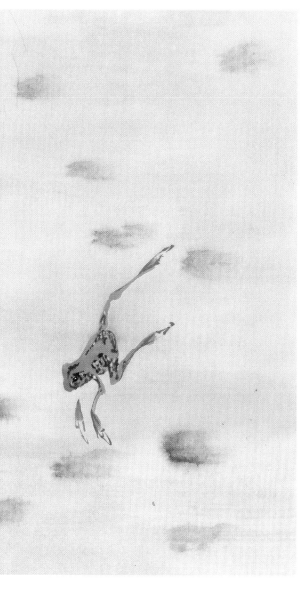

pressing down with the heel to form a rounded shape. Use dark red to add the toes and black for the markings, which must be put on while the painting is wet. Add gouache yellow or light green to some of the black splodges. Surround the bottom of the eye with orange and put a gouache yellow stripe above it.

When putting a wash on a painting of aquatic creatures (see page 117), it is helpful to apply it to the front of the picture to add to the illusion that the animals are beneath the water. Adding reeds and lily pads before the wash has dried (see page 71), as in figure 71, also enhances the watery effect.

## Common mistakes

The commonest fault beginners make when painting outlined fishes is a tendency to use their white too thickly, with the result that their fish look heavy, lifeless, and not at all watery. Head shape sometimes causes trouble, too; beware of making your fish look like a dolphin! Shape causes problems in freestyle paintings as well, especially in Lingnam-style fish: heads tend to become very narrow and bodies elongate alarmingly. You may also have difficulty with colour running when doing fish, but do not worry about this too much unless you find you are losing the shape. A little blurring round the edges of your fish adds to the watery effect.

Crabs and prawns seldom create many difficulties in painting, although crab legs sometimes wander rather indecisively. Try not to use too many strokes when doing frogs.

*Figure 77* Frog. *The lily pads are added before the wash is completely dry*

again with the heel and move it gently to either side to make the back. Add the legs by using only one stroke for each but varying the pressure in order to achieve the thickening for the thighs and calves, and splaying the ends to create the webbed effect by pressing the brush down quickly then lifting it cleanly off the paper. For the belly, load your brush with light colour and tip it in darker. Position the brush so that the tip forms the chin and pull backwards,

# PAINTING BIRDS

It is perhaps in *gongbi* paintings of birds that the drawbacks of the Chinese habit of copying show up most clearly. Although they are often decorative, birds in Chinese paintings are frequently static and occasionally anatomically unrealistic. In paintings of birds artists have shown a tendency to concentrate on using the correct brush stroke at the expense of conveying the nature of the subject. There are, of course, many very beautiful *gongbi* bird paintings and some which would grace any bird watchers' manual for accuracy. However, I personally feel they sometimes lack that essential element of movement that is so extraordinarily well captured by successful *xieyi* bird painting. You can avoid some of

the pitfalls of overstylization by remembering the moral of the story about the painters of the ducks (see page 19). Look at birds; see how they fly, land, perch and eat.

## Small birds: *gongbi* style

As you will see from figure 78, *gongbi*-method birds should first be drawn with a fine-pointed brush. Start by drawing the eye and the beak in black ink. With grey ink and a feathered brush, lightly outline the head. Next put in the black wing feathers with a bamboo leaf stroke. Again with grey and a feathered brush, add the back and the breast. Lastly, put in the tail and the legs. Obviously the shape of the bird should be varied according to the species, as should

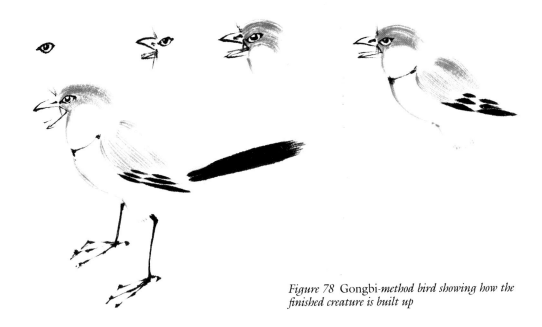

*Figure 78* Gongbi-*method bird showing how the finished creature is built up*

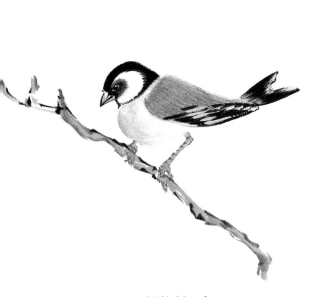

*Figure 79* Gongbi *bird in colour*

the colouring, which, as you will by now expect in a *gongbi* painting, will be done by blending. Remember to blend from light to dark. Once you have filled in the basic colours, put in the markings such as the little cross bars on the wings. Add a touch of white to the eye to bring it alive. If you want to give your bird a speckled breast, fill a small brush with the predominant light colour you want and tip it in a darker tone, then use it with a dabbing motion, overlapping your strokes. Figure 79 illustrates a *gongbi* small bird in colour.

## Large birds: *gongbi* style

In figures 80 and 81 large birds are treated in the detailed manner – the method is essentially the same as for small birds. You should begin by outlining the eye and the beak, and then draw in the head, wings, back, breast, tail, legs and feet. The peacock on page 16 was also painted in this way.

Some large birds are painted in meticulous detail with many of their feathers put in individually. Figure 82 shows a selection of different feathers. In each case, start by marking in the spine in light ink. Using a small split brush, work outwards from the

*Figure 80* Owl. *This is painted by the* gongbi *method and shows the use of the speckled technique. The moon is painted in white gouache on the back of the painting so that when the wash is added to the front an effect of clouds scudding across the moon is achieved. The sky effect is created by applying a variegated wash*

spine with a feather stroke. Then reverse the stroke and feather inwards from the outer edge. Next, add a wash of the predominant colour of the bird. Emphasize the spine with black and highlight it with white if this is appropriate to the colouring of your bird. You may also need to highlight the edge of the feather. This basic method for painting feathers can be adapted for most shapes, colour schemes and sizes.

Normally the breasts of birds are painted with blended colours and do not have the feathers marked individually, although ducks are sometimes an exception to this rule. The crane's tail (figure 81) is done with sweeping, bamboo leaf strokes. When painting a peacock, as illustrated on page 16, it is advisable to establish the overall shape of the tail by marking the tail feathers lightly in grey. If you cannot obtain any Chinese or Japanese gold paint for these

*Figure 81 A crane is a symbol of longevity which often occurs in paintings alongside pine trees*

*Figure 82 A selection of feathers. A feathered brush should be used for the smaller feathers; for the larger ones, it is more effective to apply very fine, tapered, individual strokes with the tip of a small brush*

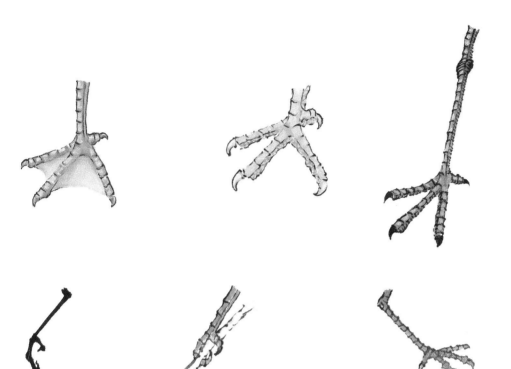

*Figure 83 Birds' legs and feet. To create a
spotted effect, the spots are put in with gouache
white or gouache white mixed with yellow before
the overall colour of the leg or foot is added. High-
lighting on the front sections of the legs and on
the tops of the feet should be blended in on top of
the colour*

feathers you can use gold plaka. However,
you will need to add this after the picture
has been mounted as it tends to wash off
otherwise. Figure 83 gives some examples
of the legs and feet of birds also done by
this detailed method.

## Small birds: *xieyi* style
Watching birds is essential if you are going
to paint freestyle ones which successfully
convey movement and life. Small freestyle
birds are begun by painting either the belly
or the back, depending on the angle of the
bird. For figure 84, take a soft sheep-, goat-

*Figure 84 Small* xieyi *bird showing how the
creature is built up beginning with the breast. It is
vital to do a* xieyi *bird 'in one breath' so that the
colours blend. It is equally important to have
strong black ink and good colour tones if you want
your bird to look lively*

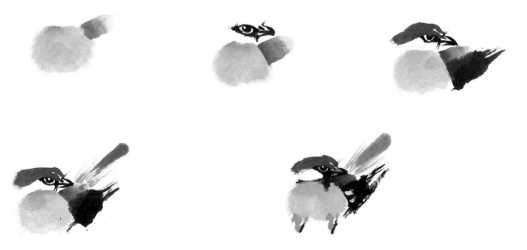

or rabbit-hair brush and saturate it in the light breast colour. Tip the brush with darker colour, then place it so that the darker tone will come at the chin and press down firmly onto the paper, moving the brush to make the shape of the bird's chest. Try to do this in one movement. Lift the brush and split it, then feather the edges of the breast. Fill your brush with a darker colour and paint the shoulder area of the back with a sideways stroke. When you have done this, change to a firmer brush, preferably a horse-hair one if you have it, and put in the eye and the beak with bold strokes. For the top of the head, fill your brush with

ink or colour and place it so that the tip forms the front of the face above the beak. Lay the brush down firmly, turning it slightly so that the heel meets the shoulder. Make a second stroke for the top of the head in the same manner, but this time include a small bump above the eye by moving the brush slightly sideways while you are laying it down. You should never use more than two strokes for the top of the head. Do the wing next with a bold side stroke, augmented by one or two pushed vertical strokes, then add the tail. Paint the markings round the eye and those on the cheek, chest, head and wings. Colour the beak and put in the tongue if the mouth is open. Highlight the eye with a dab of white, and also fill in the cheek with white if appropriate. Lastly, add the feet.

The bird in figure 85 is done by exactly the same method except that this time the back is painted first with the soft brush. The feathering technique should be used not to puff up the chest but to pull the stroke backwards, providing the base of the tail. The black tail feather is done with a stroke pushed outwards from the body. Do the head as before. Leave the chest until after you have put in the chin area and the wings. Note that birds seen from this angle show more leg than those seen face on: figure 86 gives some examples of legs and feet suitable for small birds.

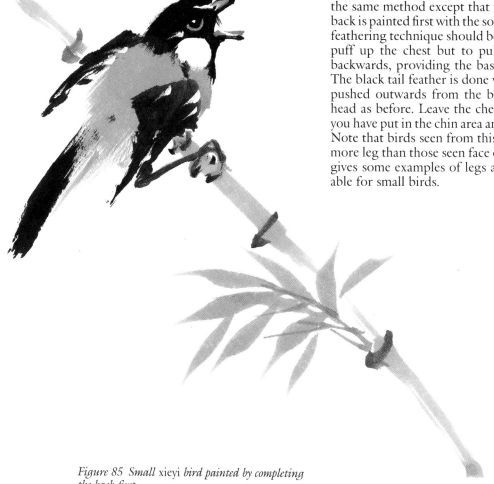

*Figure 85 Small* xieyi *bird painted by completing the back first*

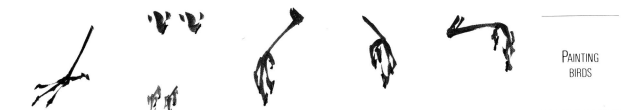

*Figure 86 Feet and legs for small* xieyi *birds. It is important not to be too tentative when painting these. The joints are done in the same manner as the joints on bamboo side branches, without breaks*

As with *gongbi* birds, you can vary the shape, size and colouring according to the species. It's important to pay particular attention to the shape of the beak in this context, as this readily distinguishes one species from another. Remember that a freestyle bird should always be completed 'in one breath': your first stroke should not have dried before you have added the last one. If you are doing a group of birds you must do them one at a time and not be tempted to do all the breasts or backs before adding all the heads and wings. Make sure your colour is rich and your ink thick and black if you want your birds to look alive.

## Large birds: *xieyi* style

For large freestyle birds you once again begin with the eyes and beak, which are done with thick firm strokes, using a horse-hair brush if possible. For the egret in figure 87, you next outline the bird with a dry, rough line. Then damp the bird and shade in the darker areas. Put a thin white wash over the whole bird, highlighting the top of the head, chest and parts of the back by blending in denser white. Add the long feathers with thick white. The legs are done without an outline and the markings are added before they dry.

When you first attempt to do compli-cated large birds, such as the male man-darin in figure 88, you might find it easier to sketch them lightly in charcoal before putting on the colour. This will help you to keep track of the shape as you work. To create the dappled effect of feathers, use a brush suitably loaded and let the brush make the feather shapes for you: press it

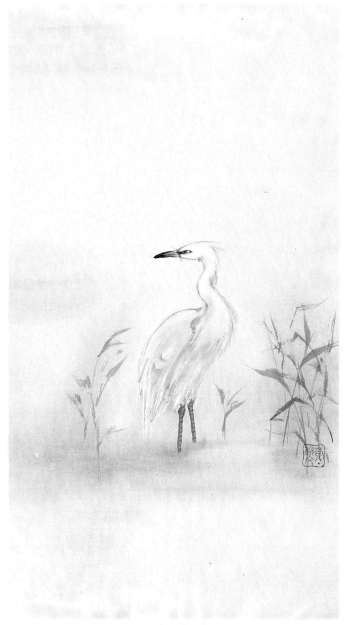

*Figure 87* Egret. *This is painted in the Lingnam manner*

89

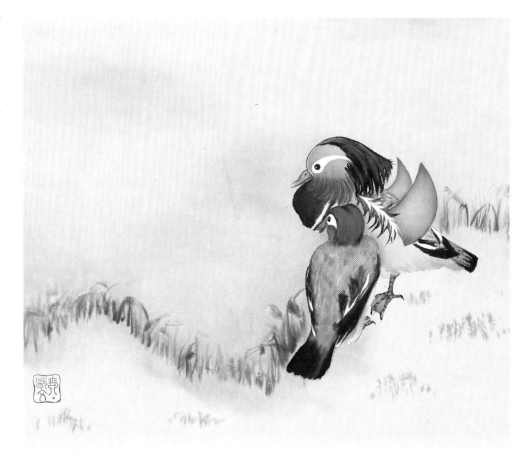

*Figure 88* Mandarin Ducks. *The snowy effect, described in the chapter on washes, is enhanced by light touches of white on the grass*

down and then lift it off cleanly. You should superimpose a few spine markings in white and black. (You can use the same dappling technique to depict the speckled breasts of small birds, either *xieyi* or *gongbi*.) The male's head, ruff and side feathers are done like the crane's tail (figure 81) but with a horse-hair brush or, failing that, a twisted ordinary brush. Paint the face and orange sails with a technique similar to the one you used for freestyle flower petals. If you find the sails start to spread you probably have too much water mixed with your colour. A small amount of spread is normal, however, and can be counteracted by blending in a new darker edge when the sails are nearly dry. For the male's breast, apply a dark grey ink wash and then add the colour on top, as you did for lotus leaves. A sky blue wash is

added to the female's head and to the male's black head and side feathers.

Other large freestyle birds are done with no preliminary outline at all. For the cock in figure 89, for example, paint the comb and the markings round the eye immediately after the eye and the beak. The neck ruff can either be done as it is here, with rough strokes of a dry horse-hair brush, or with freestyle strokes of a brush loaded with three shades of colour. Use a soft brush for the body. The tail feathers should be flamboyant and preferably done with a large horse-hair brush. The legs and feet are done without an outline as before, with the markings added immediately. The hen is painted in exactly the same way, but remember that her comb is much smaller and her neck shorter than the cock's. She also lacks the extravagant tail feathers.

*Figure 89* Rooster and Hen. *This is painted in the* xieyi *manner*

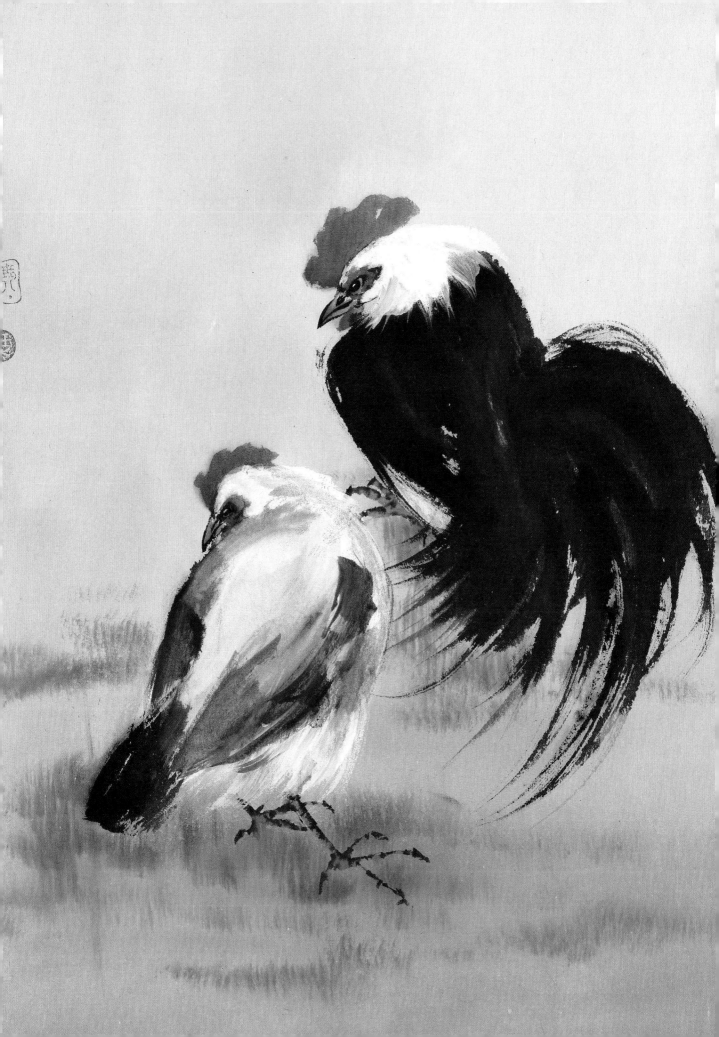

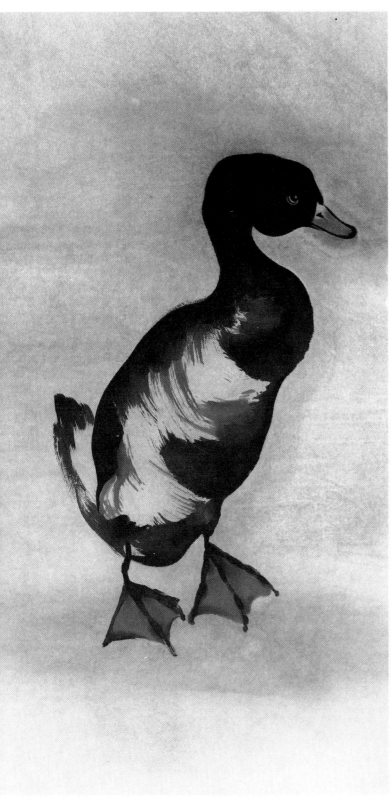

The duck in figure 90 is entirely done with a large wolf-hair brush. Begin with the eye and the beak and then paint the head, using a fluid movement of the brush, which must stay in contact with the paper. Do the body in the same way. Add the wing and tail markings, with darker ink, and put in the feet last.

The bird of prey in figure 91 combines the techniques of the outline method used for the egret (figure 87) and the totally freestyle method used for the cock and ducks. For instance, the head is done by the egret method, whereas the feet are done like the cock's feet. The wings, back and tail are painted with sweeping side strokes of your largest brush, preferably a horse-hair one. The leg is done with free feathered strokes.

## Common mistakes

By far the commonest problem people have with outline-method birds is with the legs and feet. One of my fellow students spent weeks just being shown how to do feet since she always left these for Professor Chen to do when he came round. Remember to make the feet large enough to support the bird – birds have surprisingly large feet – and ensure the legs look firm and strong. Remember, too, that birds have chests, not stomachs – beginners often make them look egg-bound! Pay attention to the positioning of eyes and beaks, and keep the tops of the heads fairly flat. Above all, do not be in too much of a hurry, especially if you are painting a large bird: haste results in messy-looking feathers. Treat the portrayal of a detailed bird as a labour of love and be meticulous about each feather.

With small *xieyi* birds the problems are more varied, but shape, legs and feet again cause a large proportion of them. Make sure you keep the weight distribution up in the chest area and not in the belly, and use firm, bold strokes for the legs and feet. Another very common fault with freestyle birds is using too many strokes. Remember: use only one stroke for the back and one for the breast; two strokes at most for the top

*Figure 90 This duck is painted with the fewest possible number of strokes*

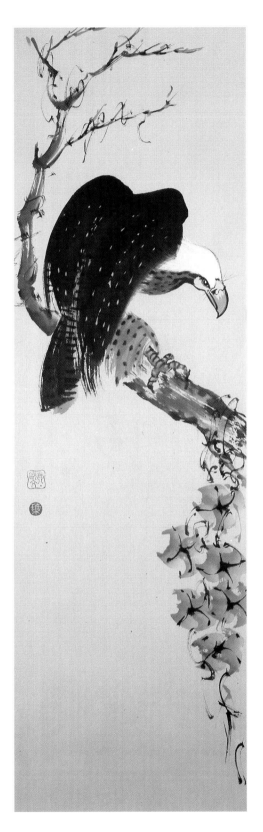

of the head; and a maximum of three for the wing. Overworking a freestyle bird destroys its spontaneity and robs it of its main attraction, which is its movement. You must also make sure that your ink is thick and black, and that your colours are bright and bold – beginners often use rather watery tones.

Large freestyle birds do not seem to cause as many problems as small ones, although there is often a tendency to make them too neat and tidy. You must always use bold strokes and, as with the small birds, good black ink and firm colours.

*Figure 91* Bird of Prey after Hau Chiok. *This shows how different techniques can be successfully combined in one painting*

# PAINTING MAMMALS

The approximate association of *gongbi* with the outline method that we have been able to make up to now breaks down completely when it comes to mammals. Although you can naturally portray any animal you want by drawing it in outline with a fine-pointed brush, traditionally Chinese painters have hardly ever depicted animals in outline. It is the meticulous detailing of fur and other markings that usually distinguishes a *gongbi* animal painting from a *xieyi* one. The exceptions to this rule are the famous *gongbi* paintings of horses done by Giuseppe Castiglione which were done in outline first. Generally with animals, however, the line between *gongbi* and *xieyi* is often very hard to determine.

Remember to watch animals as you do birds. Observation is by far the most useful technique you have. You should by now be able to work out for yourself how to tackle an animal by outlining it, so I do not intend to go into details again here. Concentrate on making the shape of the beast natural and strive for a feeling of movement. Remember that a feathered stroke can suggest fur as easily as it can feathers or grass. For outlined animals, use the lessons in colouring that you learnt for fish and birds.

## Horses

Because horses have always been an important theme in Chinese painting I shall begin with these. Even the Yuan dynasty (*c.* 1279–1368), which was not remarkable for its painting, produced a very fine calligrapher, Zhao Mengfu, who is equally remembered for his pictures of horses. To the Chinese, the horse stands for perseverance and speed. The method of painting

them is very reminiscent of that used for depicting rocks and branches in that the shading is put in first to create form and the outline is added afterwards.

For the horse in figure 92 begin with the shading of the head and neck. Add the belly with an upward movement of the side of the brush. Shade the rump and the tops of the legs where appropriate. Then recharge your brush with black ink and outline the horse with free-flowing strokes. The lower part of each leg should be done with a single stroke in the 'bone' manner. Next, add the hooves and ears, and lastly put in the mane and tail, using the minimum of strokes and the maximum of dash.

## Other mammals

Furrier animals, such as those in figures 93–7, should also have the shading done first, but no outline is added. Instead the rest of the body is completed with a light wash. The detail is picked out in black and the furry texture added with a feathered brush. You may find it easier to sketch your animal lightly in charcoal as you did with the large freestyle birds until you become practised at knowing where to put your wash. You can also achieve a very furry effect, should you so desire, by damping your paper before you begin. If you do this, however, you would be well advised to leave details like the eye and the mouth until after you have applied the wash because it will then be easier to position them properly.

When you are painting furry animals you may like to reflect that several of them have symbolic meanings and beliefs attached to them. The rat, for example, can be an emblem of timidity and meanness, but on the other hand it is also seen as representing

94

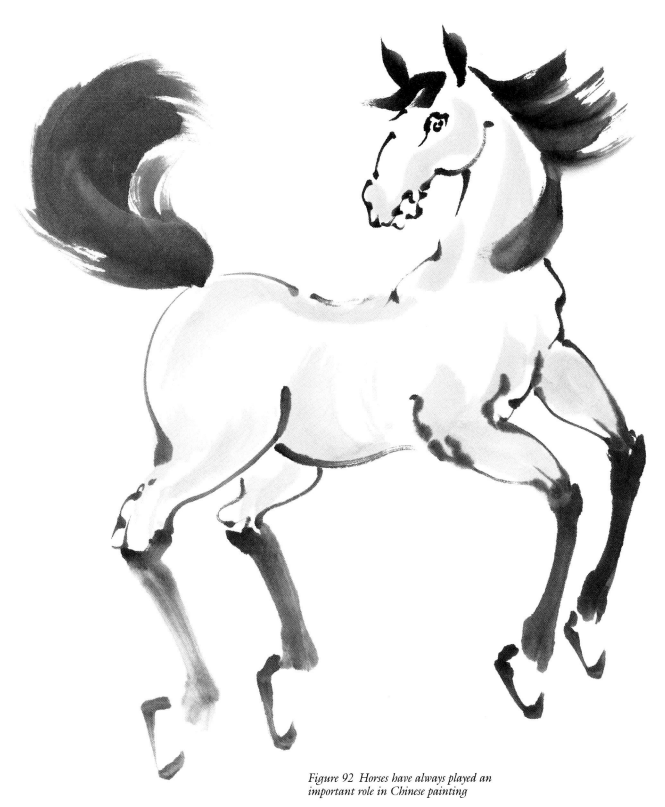

*Figure 92  Horses have always played an
important role in Chinese painting*

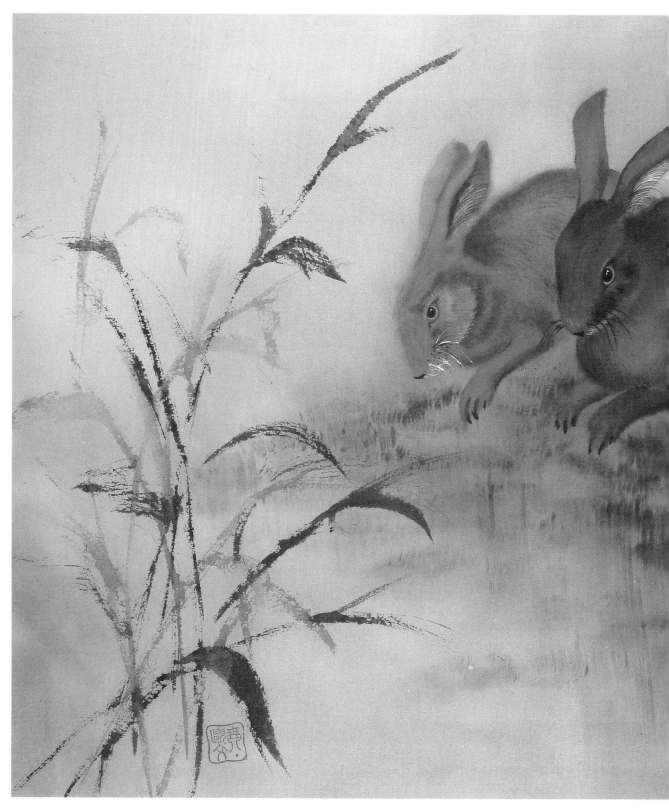

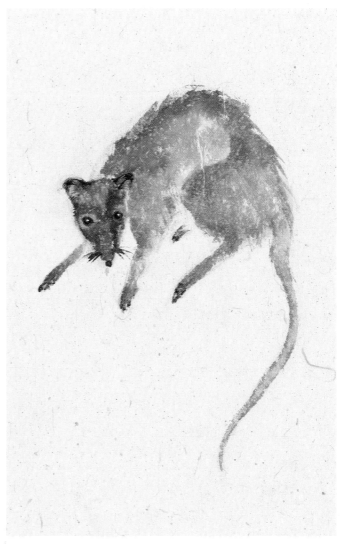

LEFT: *Figure 93* Baby Rabbits. *These are worked on wet paper to create the soft, furry effect* (private collection)

ABOVE: *Figure 94* Rat. *The basic shape is worked wet and then drier texture is added to the fur with a rough brush or a twisted wolf-hair one*

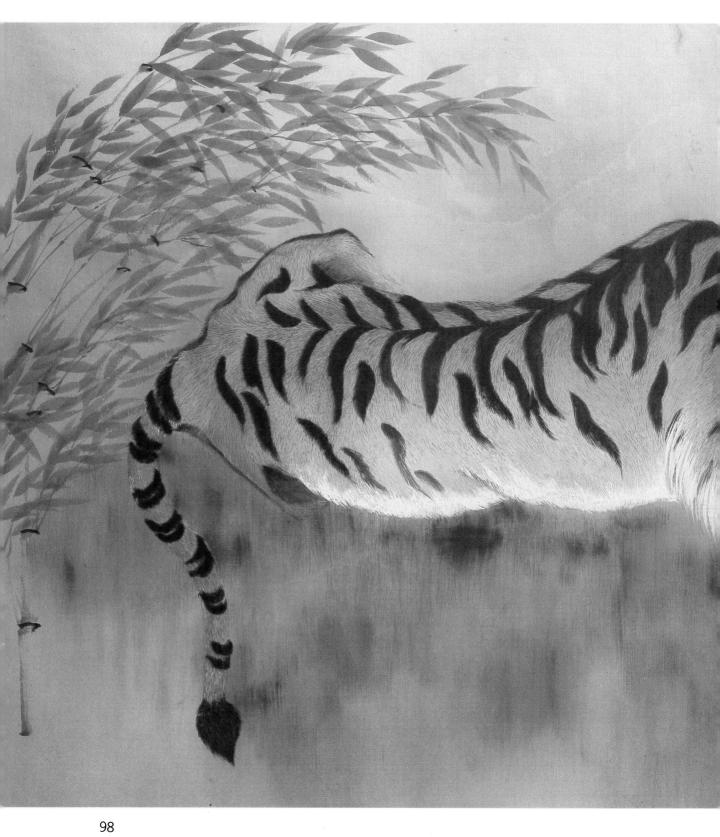

98

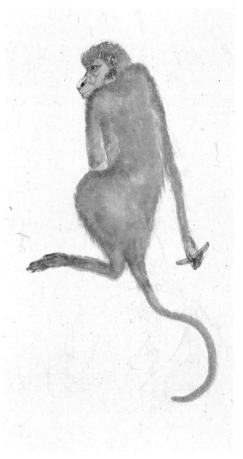

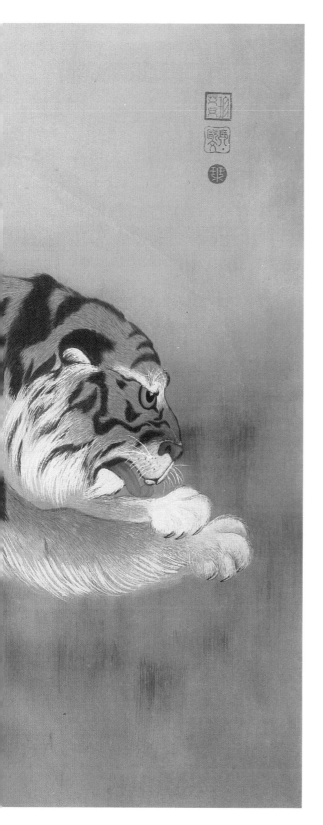

LEFT: *Figure 95* Tiger. *Again the basic shape is worked on damp paper, but this time the fur is added much more painstakingly with feathered strokes of a good wolf-hair brush and different colours. The texture of the wash is achieved by applying dry colour with a wash brush before the overall wash has completely dried*

ABOVE: *Figure 96* Monkey. *The fur texture is created by applying grey and black shading onto damp paper slowly so that it spreads and blurs*

99

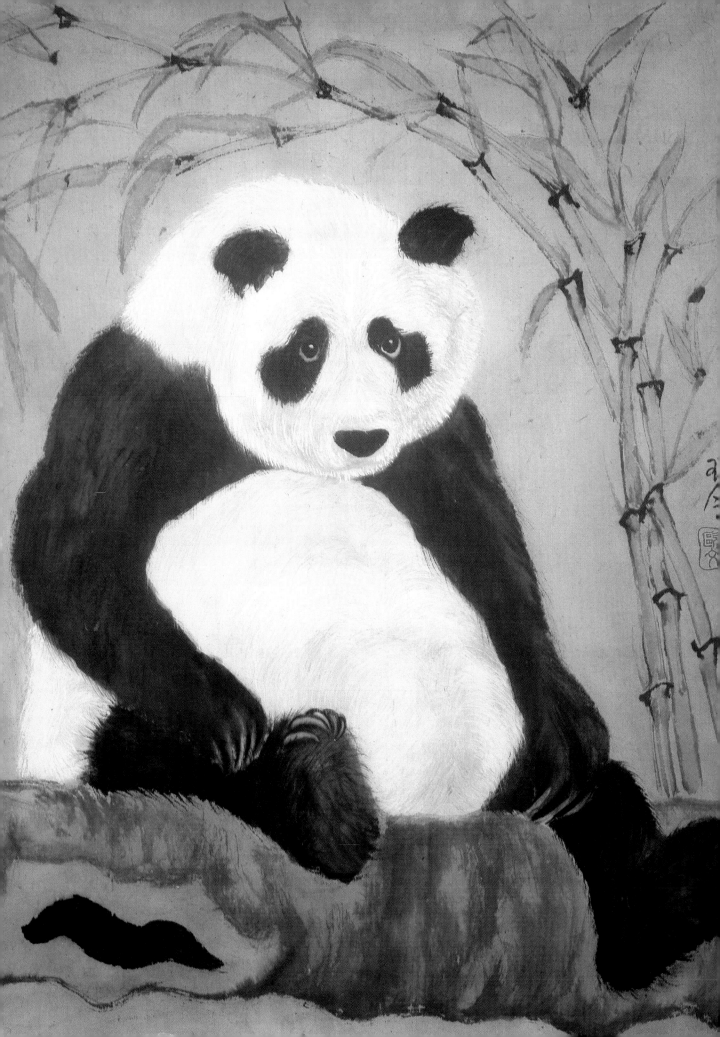

*Figure 97* Panda. *The shading on the white sections is achieved by applying it underneath a white wash, slowly so that it 'furs'. The white highlights are added by blending in denser white, with some feathered strokes superimposed for additional furry texture. The black sections are worked wet and then drier texture is added to the fur with a rough brush* (private collection)

---

industry and prosperity. The tiger is regarded as the king of beasts; it is dignified and stern as well as ferocious and daring. The monkey represents ugliness and trickery, and is believed to control witches and hobgoblins; it is also, however, an object of worship, particularly for the sick or the unsuccessful. The cat is seen as rather an unlucky emblem. The coming of a cat to a house is thought to signal the coming of poverty, so it is perhaps not surprising that the cat does not feature very largely in Chinese painting, although it occurs from time to time.

For some animals brush strokes are used to provide outline and body simultaneously. Each stroke has to be carefully placed in such a way as to give form to the animal. The cat and mouse illustrated on page 14 and the panda in figure 98 are done on dry paper. They are made to look furry by using a wet brush and by working the body shapes slowly so that the ink spreads. For the cat, put in the shapes of the head, ears, body, legs and tail, leaving spaces for the

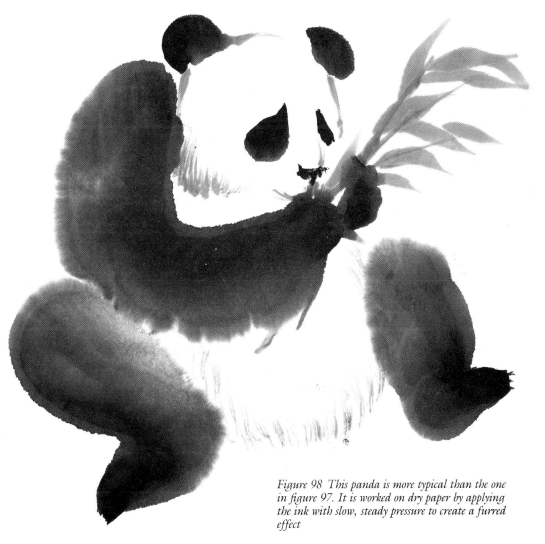

*Figure 98 This panda is more typical than the one in figure 97. It is worked on dry paper by applying the ink with slow, steady pressure to create a furred effect*

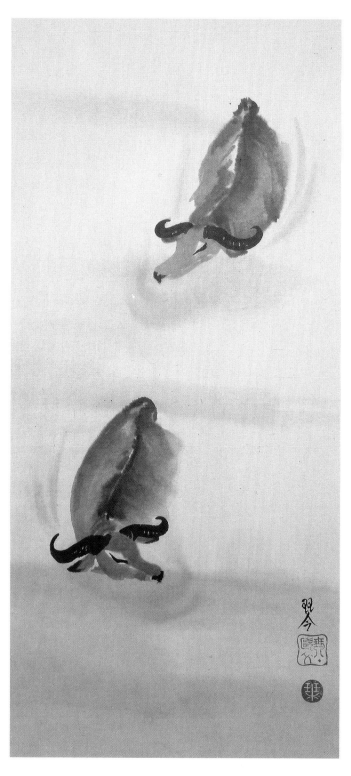

eyes. Add the dark markings while the grey is still wet. Lastly, put in the details of the eyes, whiskers, nose and mouth. For the mouse, do the head, body, tail and ears in grey, using one stroke for each. Add the black details. For the panda (figure 98), place the eye patches with single strokes. Add the ears and the black areas and with a split brush outline the white parts with grey ink.

The water buffaloes in figure 99 are done by the same method but with a slightly drier brush and working faster to avoid too much furring. Start with the head and, leaving gaps for the eyes and horns, lay down each stroke carefully, keeping the animal's shape clear. Add the eyes, horns, nose and other details in black. Use as few strokes as possible, preferably only one for each section of the animals. Have enough ink on your brush to complete the stroke. The chapter on washes explains how to represent water and its movement.

## Common mistakes

Most of the mistakes beginners make when painting mammals are caused by our old favourites: overworking – too many strokes will destroy animation; and lack of observation – this will result in unlikely shapes.

*Figure 99* Water Buffaloes. *These are painted with as few strokes as possible on dry paper*

# PAINTING PEOPLE

Unlike other mammals, people are almost always depicted in outline. This is true of both *gongbi* and *xieyi* paintings. For *gongbi*-style figures, follow the instructions for flower painting, remembering to use a clean, fine line for the outline and to blend the colour carefully. Traditional paintings of people seldom showed any shading on the face and usually none on the clothing, but you can if you wish blend shadows into robes and even onto faces as I have done in figure 100.

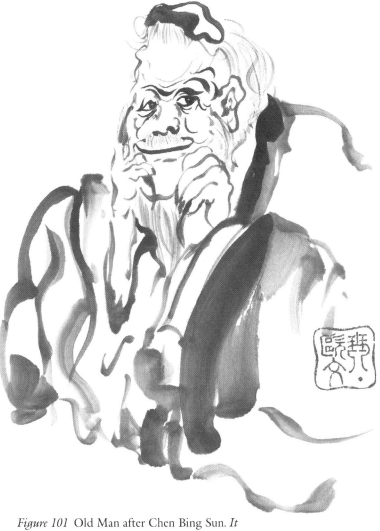

*Figure 100 Figure painted in the* gongbi *style*

*Figure 101* Old Man after Chen Bing Sun. *It is important when 'drawing' with the brush, as for the face, to vary the pressure if you want to achieve texture and liveliness*

103

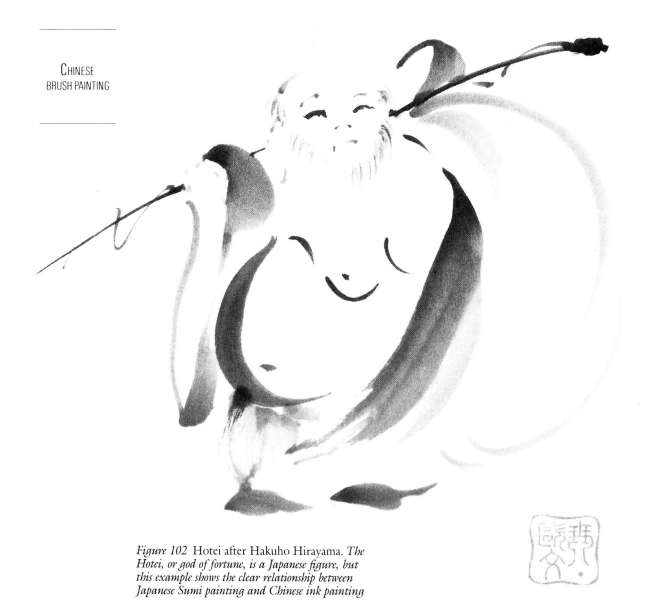

*Figure 102* Hotei after Hakuho Hirayama. *The Hotei, or god of fortune, is a Japanese figure, but this example shows the clear relationship between Japanese Sumi painting and Chinese ink painting*

*Xieyi* figures do not have shadows, however. They are done with expressive brush strokes and any colour is added as a very light wash. Figures 101 and 102 give examples of this technique. Figure 102 is a copy of a Hotei or god of fortune, a figure more commonly encountered in Japanese painting.[1] However, the strokes used for this Sumi rendition are the same as for Chinese black and white *xieyi* painting.

1. *Sumi-e Just For You – Traditional 'One Brush' Ink Painting*, Hakuho Hirayama, Kodansha International, Tokyo, New York and San Francisco, 1979.

# PAINTING LANDSCAPES

There are probably more conventions governing the painting of landscapes in the Chinese tradition than there are for any other subject. Indeed, in the past painters have occasionally become bogged down by these conventions and have looked to earlier eras of painting in the hope of returning to a style relatively untrammelled by rules and prohibitions.

Apart from the monk artists of the Song dynasty (*c.* 960–1279), landscape painters have usually enjoyed the highest status among artists. In the past, scholar painters were the only ones who thought it was worthwhile to travel to look at actual scenery, and even they gave a fairly low priority to accuracy in their paintings of landscapes. Until comparatively recently, Chinese painters have not seen it as their role to provide a representational image. As with other subjects, they seek to convey the spirit of their subject. They have in fact sought to remain detached from painting specific localities, feeling that this might interfere with their efforts to convey spirituality. In Chinese philosophy great emphasis is laid on meditation and retreat. Quite obviously society could not function if all its officials and rulers pursued this ideal to its logical conclusion and retired from life to indulge in solitary meditation somewhere in the wilderness, so painters in dynastic China provided imaginary scenes for people to retreat into by contemplation. Traditionally, therefore, subjects in Academic pictures were edifying, and landscape painting became the most prestigious art form.

Landscape painting perhaps shows the most obvious changes in recent years. Many modern Chinese painters use Western perspective and have abandoned many of the conventions. Nevertheless, the landscape painting that is being done in China today and by Chinese painters in the West represents very much a development of the traditions and not their abrogation. An understanding of these traditions is therefore necessary for the learner.

## Traditions in landscape painting

Traditionally Chinese artists have treated perspective quite differently from Western artists. Their paintings have no vanishing point. The overall scene is viewed as if from above, while the elements in it are viewed from the side. You may, for example, have a tree in the foreground growing as if you were standing on the same level as it. Above it you may have a mountain that is obviously behind the tree from your viewpoint but which is placed on top of it in the painting. Curiously, the only individual element of a picture that is usually depicted as if from above is a building. Trees and figures beside the building are seen face or side on, however.

Similarly – and this goes for all Chinese painting, not just landscapes – the light need not come from only one point. Each element in a painting is shown as if lit from the point that will most enhance it, without reference to the other elements of the picture.

A landscape painting normally has three parts: foreground, middle ground, and distance. Sometimes these are not given equal value and occasionally the middle ground or the distance may become somewhat token; but all three are nearly always present in some degree. The foreground is at the bottom of the picture, with the

Figure 103  A selection of trees for landscape paintings

middle ground above it and the distance above that. You should always begin by painting the foreground and work upwards. Traditionally, skies were left unpainted, as was water quite often, but nowadays some artists treat the sky as their distance and depict it with ink and colour.

When embarking on a landscape you should start with a prominent feature of the foreground, such as a tree. Make this the reference point for your composition. Most Chinese landscapes contain evidence of man's presence – some houses, a boat, a figure or two – but this should not dominate the foreground. It is as if the artist is telling us of man's insignificant role in nature.

Traditionally, landscapes are first completed in ink tones and colour is added later in light washes. Some schools of landscape painting use more definite colours, particularly greens and blues; these are also added to an ink painting.

## Landscape elements

By now you will have mastered most of the techniques you need for painting landscapes. However, you also need to be able to portray the individual elements with which you can build your traditional Chinese landscape, and this section concentrates on these.

Figure 103 illustrates examples of different kinds of tree. These are done in the same way as plum branches and pine trees, but the shapes and shading are adapted to suit the species you want. Different leaf patterns are given in figure 104, and figure 105 shows trees as they are depicted in the middle ground and distance. When colouring the foliage of bushes and trees, damp an area much larger than the one you want to

Figure 104 A selection of leaf patterns for landscape paintings

Figure 105 A selection of trees for the middle ground and distance in landscape paintings

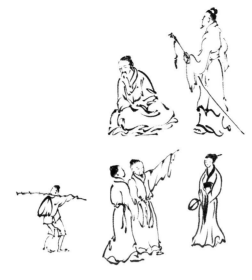

*Figure 106 Simple human figures suitable for landscape paintings*

*Figure 107 Boats typical of those found in landscape paintings*

colour. Then add a wash, which should extend slightly outside the inked drawing to give a halo effect.

Figure 106 includes a selection of the kind of simple figures that frequently occur in Chinese landscape paintings. They are drawn with a fine-pointed brush, as are the boats in figure 107. Figure 108 shows a freestyle boat and for this you should load your brush with two tones to paint the main shape with a single stroke. The sail is done by moving the brush, again loaded with two tones, from side to side. Figure 109 gives examples of buildings and bridges

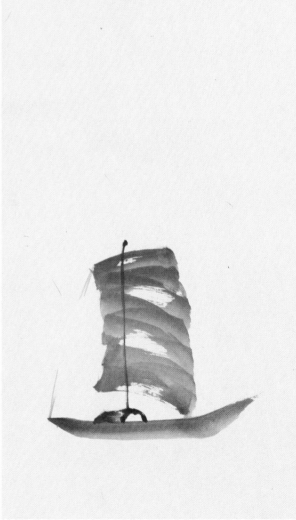

*Figure 108 Freestyle boat*

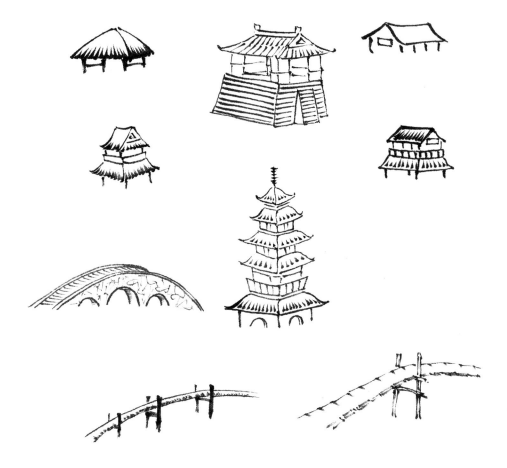

*Figure 109 Buildings and bridges suitable for landscape paintings*

typical of those found in landscape paintings. When you colour buildings, boats, people and the trunks of trees, make sure these do not stand out too much from their surroundings.

Obviously you may want to paint landscapes which contain Western boats, buildings and people. You can easily do this, using the same techniques and simply adapting the shapes.

For rocks and mountains you should refer to the section on painting rocks (see page 52). Rocks in the middle ground are done in lighter tones than those in the foreground, and distant hills and mountains are done in very light tones. Some of the different brush strokes used to depict mountains and hills in landscape paintings are illustrated in figure 110. Sometimes,

however, distant hills are shown very mistily by means of a wash-like technique rather than by brush strokes. In figure 111a, for example, the hill has a clear outline but its base fades into the mist. To achieve this effect, wet a band of the paper just below where the ridge of your hill will come. Fill your largest brush with very watery ink and tip it in slightly darker ink. Using the tip to make the crest of the hill, roll the brush over the paper, pressing the heel down into the damped portion of it. For a mountain totally shrouded in mist (figure 111b), wet the whole area so that the edge of your mountain bleeds into the sky area.

Colour washes on mountains, land and rocks are fairly self-explanatory. Foreground colours can be brighter than those in the middle ground, which in turn should be more dominant than those in the distance; but take care not to make your painting too garish. Be careful also to blend

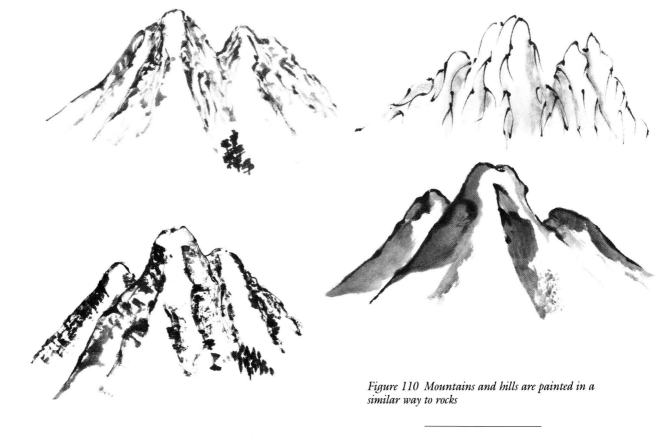

*Figure 110 Mountains and hills are painted in a similar way to rocks*

your colours well; remember to use the heel of your brush. If you want to have snow-capped peaks to your distant mountains, wet the tops before you apply the colour to the lower slopes, and run the colour into the wet portion to prevent a harsh edge. Similarly, misty areas at the bases of mountains and foothills should be damped and have the wash run into them to avoid a watermark forming.

When it comes to suggesting water, it is not necessary to use colour. Still water is often left unpainted or with only a very light wash run into the edges and under rocks and boats. To do this, wet the whole area and use only a very little colour – if you doubt that it will show up at all you have probably got the dilution about right – running it into the areas where you want it with the tip of an otherwise clean brush. Waterfalls, such as those in figure 112, are usually left unpainted, although sometimes water flow lines are put in. More often, however, the impression of running water

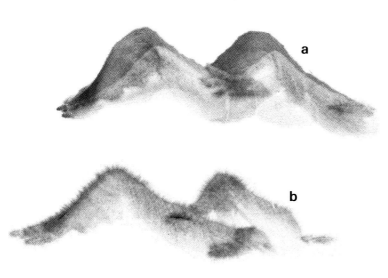

*Figure 111 Distant hills, showing different misty effects*

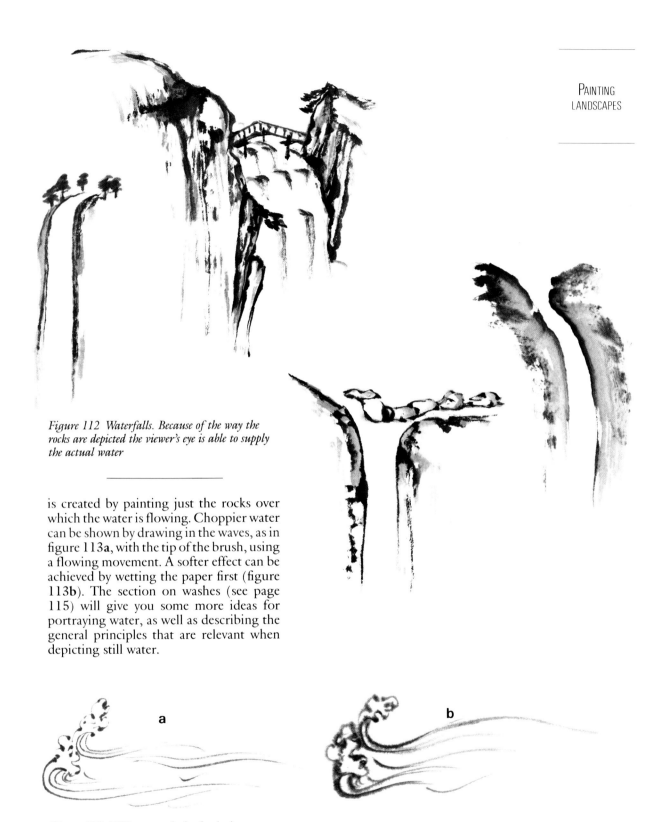

*Figure 112 Waterfalls. Because of the way the rocks are depicted the viewer's eye is able to supply the actual water*

is created by painting just the rocks over which the water is flowing. Choppier water can be shown by drawing in the waves, as in figure 113a, with the tip of the brush, using a flowing movement. A softer effect can be achieved by wetting the paper first (figure 113b). The section on washes (see page 115) will give you some more ideas for portraying water, as well as describing the general principles that are relevant when depicting still water.

*Figure 113 Different methods of painting waves*

*Figure 114 Clouds with sharp edges are achieved by leaving areas of the paper dry so that the colour wash creates watermarks when it encounters them*

For skies, too, you should consult the wash section. Be particularly careful not to have your colour too heavy when applying skies. Remember that once a picture is mounted, the colours tend to show up more clearly, so bear this in mind when mixing your washes. Cloud effects can be created by leaving sections of paper clear of paint. If you want your clouds to have definite edges, you must also leave these clear sections dry – as your wash runs up to each dry section it will leave a watermark (figure 114). Softer-edged clouds are the result of wetting the whole area before adding the light wash to the unclouded areas of the sky.

Figure 115 illustrates a fairly formal typical Chinese landscape, whereas the painting in figure 116 is painted in a more freestyle manner. Both these paintings incorporate the elements described earlier and are included here for you to practise putting these elements together. For more experimental techniques in landscape painting, see page 119.

Once you have grasped the techniques of landscape painting you will probably want to apply them to your own favourite scenery. You will find this easier to do if you happen to like painting mountains. Flat landscape can of course be depicted in the same three-tier perspective, but it tends to look somewhat strange to most Western eyes. If you are painting flat scenery you would probably be well advised to experiment with perspective. A number of modern Chinese painters are departing from the rigid rules without undermining the Chineseness of their paintings. Many of them have adopted Western perspective while retaining the freshness of their approach which enables them to use space as an expressive element in their continuing effort to capture the spirit of the scenery. The use of Western compositional techniques has not turned them into mere photographic recorders. You may well find some of the techniques discussed in the following chapters very useful when it comes to trying to convey the spirit of the landscape around you.

*Figure 115* Landscape. *A typical formal landscape combining various landscape elements* (private collection)

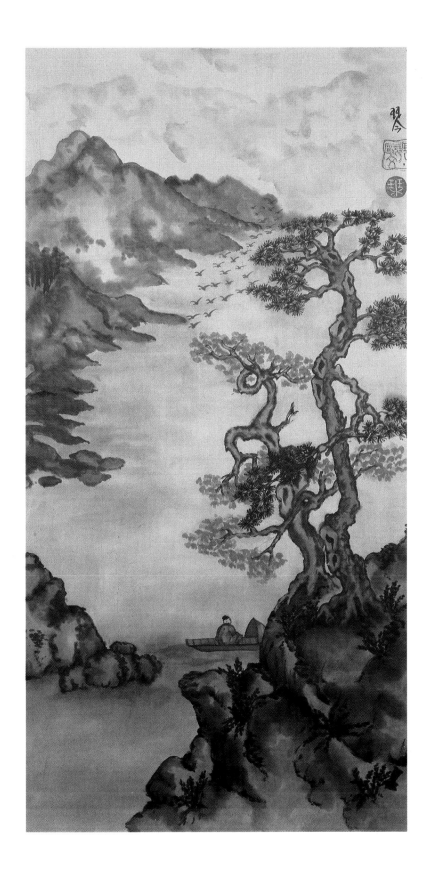

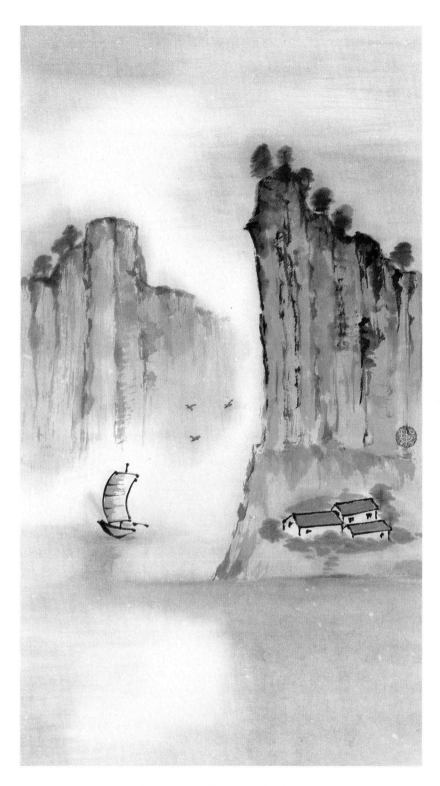

*Figure 116* Landscape after Hau Chiok. *This freestyle painting follows traditional methods*

# APPLYING WASHES

There are some styles of Chinese painting which do not use washes at all – for example, Chan or Zen Buddhist paintings very seldom have washes. Many of your paintings, however, will be greatly enhanced by the addition of one and, in some cases, a wash is an essential element of the composition.

There are a few basic rules that apply to any sort of wash. It is important that you always use a blanket to lay your picture on before applying a wash. Felt tends to become too wet for convenience and newsprint soaks up moisture unevenly, resulting in a patchy effect. Use an old blanket by all means, but it should still have some pile; a threadbare blanket will leave a crisscross pattern on your painting. You must work with a proper wash brush (see page 22) – anything else will make life unnecessarily difficult. Always damp your painting with clean water before applying any colour as this will enable you to achieve an even spread of colour. Do not swamp the picture with water; a light damping is enough. Spread each brushload of colour as far as it will go, varying the direction of your brush strokes, and make sure each new brushload overlaps a previous one so that you get an even blending – this is true even if your tones are changing and blending. Apply the wash over the subject – don't try to go round it. Never hurry a wash.

If any wet spots appear where the paper has stuck to the blanket, simply lift the paper gently and mop underneath with a tissue. This is important, otherwise the wash will dry spotty – but do remember how fragile the paper is when wet. If you find you are getting a great many spots your paper must be too wet. Try gently mopping the whole painting with tissue. If this does not improve matters your blanket is probably unsuitable.

Some washes are applied to the front of a painting and some to the back. There is no fixed rule about this. If you want your colours to stand out clearly you should put the wash on the back of the picture. If, however, you want to deaden a colour slightly or you want to create an underwater effect you should apply the wash to the front. On a landscape you will almost certainly find it easier to work from the front.

The simplest wash is an evenly applied tea wash, such as that in figure 12. Plum blossom pictures and simple studies of birds, insects and flowers often have a tea wash. It gives a mellow, slightly antiqued effect. To make one, use a ratio of six teabags to one cup of water (use Indian tea not China!). When the tea has thoroughly brewed, remove the teabags and leave the solution to cool. A tea wash is normally applied to the back of a painting.

Any even-toned wash is applied in the same way as a tea wash. If you are using colour instead of tea, make the mixture very dilute. Take particular care if you are using blue for your wash because this colour is often difficult to spread evenly and usually dries brighter than expected. Never try to mix ink with a wash as it tends to separate out from the colour.

Often you will need a wash that is more than just an even-toned colouring of the paper. You may decide to concentrate the colour behind a subject and fade it out towards the edges of the paper; you may want to have a variegated wash or to leave some areas white (see figure 80); you may

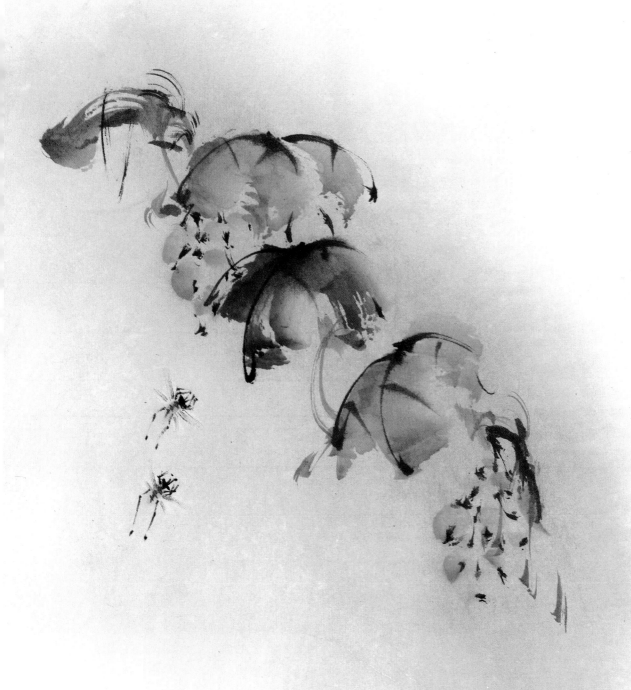

need to suggest movement in water or to depict rain, shadows or clouds; or you may want to make a rock look heavy and dense or a tree look leafy. You will be able to do all of these and more when you become skilled in the use of washes.

The technique is always essentially the same and if you can manage to achieve an even-toned background wash you should have no difficulty with the variations. The most important thing is to work slowly and carefully. Never panic. Remember that you can always add colour but you cannot take it away, so be sparing with the colours when mixing them. Chinese colours are often very subtle and it is important to remember this when applying a wash. A colour that hardly shows at all when the painting has dried will be surprisingly noticeable once you have mounted your painting. If you do put too much colour on in one place, keep calm; the solution is to spread it as far as you can and then apply still more colour to blend your overdarkened area into the rest of the wash so that the effect looks deliberate.

Figure 117 gives an example of a wash where most of the colour is concentrated behind the subject. It is done on the back of the painting. First of all, damp the whole picture, then apply the first brushful of colour to the centre of the area where you want the wash to be concentrated and spread it outwards from there, varying the angle of your brush and taking the colour as far as it will go. If necessary, apply more colour, making sure you overlap it with the already shaded area. You must spread the colour to its fullest extent, even if it appears to be going into the area you want to leave unshaded. If you do not, you will not achieve a gradual fading out, rather your wash will come to an abrupt stop.

Sometimes it is necessary to vary the colours in a wash. With a watery subject, such as the lotus in figures 56 and 59 or the fish in figure 69, the wash can be a vital element in the composition. When you are using a wash in this way as an integral part of the picture, it is better to apply it to the front of your painting. The only time you

might hesitate to do this is if you have some white or very light colours in your painting that you wish to stand out – adding the wash to the front tends to dull white and colours mixed with white. The principles here are exactly the same as before, although you may with watery subjects want to use more definite colours than you would for a background wash. It is probably best to begin at the bottom of a painting with the darker tones and work upwards to the lighter shades. Thus a lotus picture can have dark blues at the bottom, working up through varying shades of lighter blues and greens to light yellows and browns. Change the tones gradually and remember to take extra care to overlap your brush strokes so that there are no sudden colour alterations. You can add some water swirls, as in figure 69, with a large ordinary brush (i.e. not a wash brush). Load the brush with the wash tone and tip it with more concentrated colour. Apply the brush to the paper so that both tones are used. This is a similar technique to the one you used for the watery waves in the chapter on landscape.

For some watery subjects you may prefer to use different depths of the same tone interspersed with areas of white paper. This was the case for the fish in figure 73. The method here is slightly different as you will want to suggest water movement, so you should therefore keep your brush strokes working in one direction, i.e. horizontally. Leave parts of the paper white and add some darker streaks of the same colour as your wash. As before, you can add movement to your water, as in figure 99, by means of the technique for waves.

The background to the picture of mandarin ducks in figure 88 makes use of a very similar technique. The whole painting was damped and then the water wash applied to the blue area. The shore line was emphasized with an ordinary-shaped brush and the colour then blended into the blue area with a clean wash brush. This results in the uncoloured area looking snowy.

Remember that watery pictures can often be enhanced by adding reeds and lily pads before the wash has dried.

Landscapes often feature areas of still water and, as I suggested in the chapter on landscapes, it can be effective to leave these

*Figure 117 The wash in this painting is concentrated behind the image*

unpainted. Introduce shading just round the edge and under any boats and rocks. To do this it is not necessary to damp the whole painting but you will need to wet all the water area, not just the places where you intend to add colour. Naturally you can give water in landscapes a more comprehensive colouring if you want to, in which case use the techniques described above for water-like washes. Again, you need only damp the area which represents water before you apply the wash.

Rocks and mountains in landscape paintings are often coloured just by means of a wash. Remember to make the foreground tones darker and richer than those in the middle and far distance, and take care not to make the rocks too multicoloured or bright. However, you should vary the tones somewhat, especially in the foreground. You will also find that trees can often be enhanced by the addition of a soft wash over the leaf area. This gives the foliage a denser look and adds a slight halo effect to the trees. Make sure you damp an area that is larger than the one you want to colour and don't forget to fade out the shading as you did for figure 117. All these techniques are illustrated in figure 115.

As already mentioned, skies are often left white or given a light, even-toned wash. You can also blend the tones in the sky as you did for water, but using more dilute colour. Other techniques are possible, too. You can have a darker area of sky at hill-top level perhaps, lightening further up; or you can have a darker area at the top of your painting with a lighter tone behind the mountains, say, and maybe a hint of yellow to suggest sunshine (see figures 118, 119 and 120, which illustrate some of the effects that can be achieved). Clouds can be depicted as described in the chapter on landscapes or you can superimpose them on your wash in a manner similar to that used to convey water movement. Add darker or lighter tone in a cloud-like shape with a large soft brush and blend it in with your wash brush (see figures 122 and 124).

Feel free to experiment with washes. Chinese paper is amazingly strong and adaptable, and provided you remember that it is more fragile when wet you should find you are able to create some exciting effects. In the next chapter you will see that by experimenting with textures and colours it is possible to execute paintings that consist almost entirely of washes.

# MORE ADVENTUROUS TECHNIQUES

By now you will have long since discovered how versatile Chinese paper, ink, colour and brushes are. You should have mastered their use sufficiently to be able to begin to treat them a little less reverently. You may also be growing a little frustrated by the limitations of traditional Chinese painting: its formality, its stylization of scenery, its strange (to Western eyes) perspective, its 'foreignness'. You may in fact be wondering if Chinese brush painting can be made more responsive to the 'needs' of the Western eye. If so, you are ready to branch out and do your own thing; to find your own subjects and experiment with your materials and techniques. An excellent book to give you some ideas for new approaches is *Oriental Watercolor Techniques* by Frederick Wong (Pitman/Watson-Guptill, 1977).

You may also find that you want to depict particular scenes rather than landscape in general. Though this desire to paint actual scenes may be a departure from the traditional Chinese approach to landscape painting, it is only partly so. For practical reasons you cannot sit in front of a scene and paint it unless you are prepared to go to a great deal of trouble with tables and paperweights, so in fact you will be painting remembered places (although I will confess to aiding my memory with photographs). All the paintings illustrated in this chapter are of actual places, but I have endeavoured to be true to the Chinese principle and to capture their spirit. In fact, what I have tried to do is what many Chinese painters both in and out of China have experimented with in the past,

attempting to evolve techniques which provide extra dimensions for the medium. Recently there has probably been more experimentation than ever before, largely because of the impact of Western ideas which have introduced into China a fervour for 'originality'.

Most of the techniques described in this chapter rely on the strength of the paper and you should therefore only try them with good-quality paper. The cheap rolls of very white paper tend to disintegrate when wet, and nearly every variation here requires the paper to be worked damp. The first examples particularly need good paper because the technique requires it to be crumpled when wet and later stretched flat again for mounting.

To achieve the textured effect of the landscape in figure 118, first damp your paper evenly with a wash brush and then screw it into a tight ball. Very carefully disentangle it and lay it out on your felt or on a piece of old blanket. Fill a large brush with light ink and skim over the areas where you want shading. Put in some darker tones in the same way. Again using the skimming method, add some light colours. Let the paper partly dry and add some more strokes; these will not soak in as much as the previous ones and should be in slightly more definite tones. When the paper has completely dried, put in more texture in the same way, using dark ink and colours. You may find you need to recrumple the paper before you do this as your previous steps will have tended to flatten it. Once these latest strokes are dry, however, you want

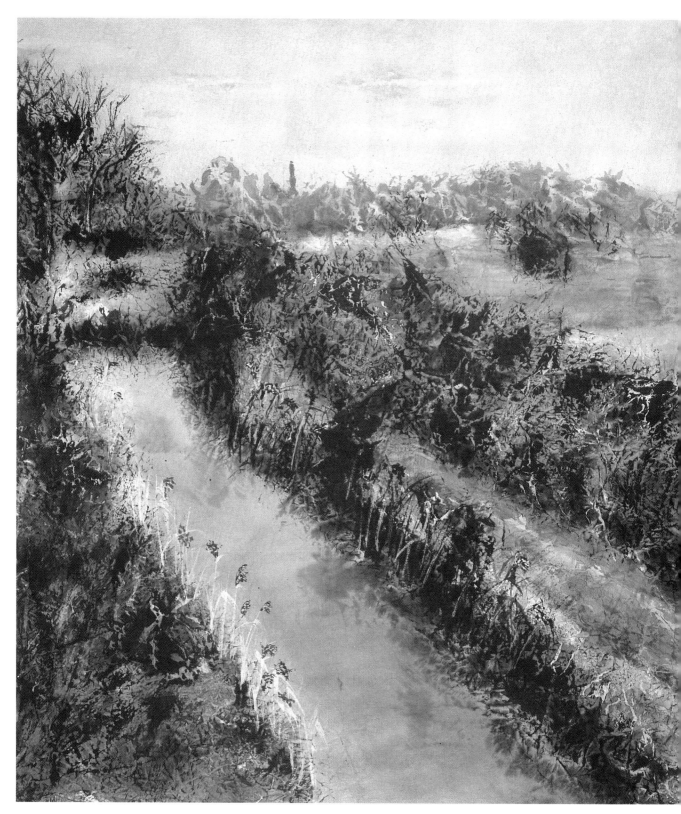

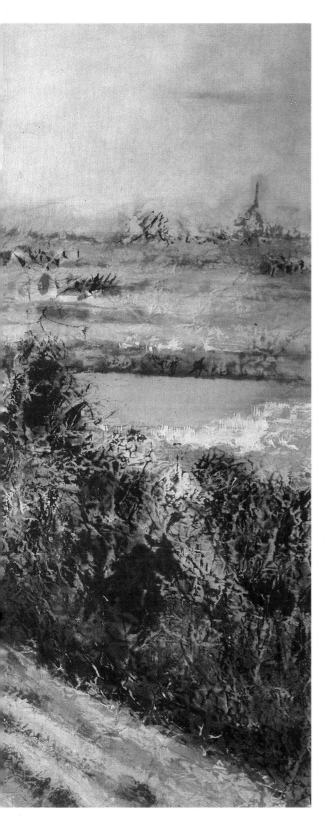

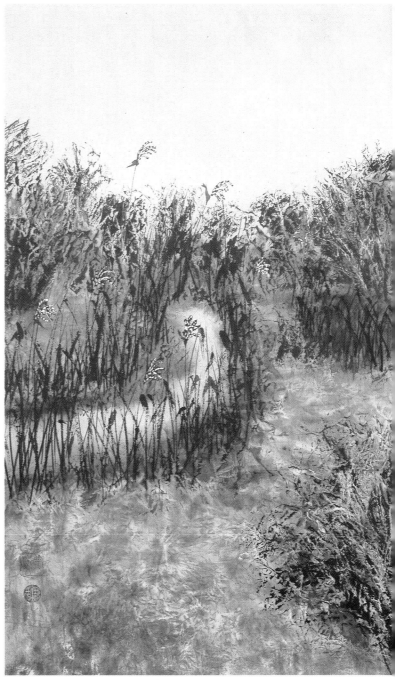

LEFT: *Figure 118* View from Wicken Fen. *The crumpled paper technique is used for this picture. The perspective is typical of a Chinese brush painting* (private collection)

ABOVE: *Figure 119* Wicken Fen, Cambridgeshire. *The crumpled paper technique is also used here, but this time the perspective is wholly Western*

121

the paper to be flat again, so redamp it to achieve this. While it is wet, add the washes for the water and the sky, then leave it to dry and put in details in the normal way. Do not worry about the slightly crumpled appearance of your picture at this stage; it will look fine once it has been mounted. Traditionally, this creased paper technique has generally been used to depict mountains, but as you can see from the illustrations here it is equally effective when used to represent dry vegetation.

Figure 118 was built up from the foreground in the traditional way and includes the three elements of foreground, middle ground and distance. Figure 119 was done by exactly the same technique, but in this case I abandoned the Chinese perspective. The distance is provided by the sky, but the focus of the painting is on the middle

*Figure 120* Wicken Fen in the Snow. *An additional snowy effect is achieved with a fine spray of white gouache*

*Figure 121* Morning Mist in Borneo (private collection)

ground and this was therefore the starting point for the picture. This also applies to figure 120, although this time appropriately snowy tones were used for the wet texturing and thick white in place of strong black for the ground. An extra powdery effect was achieved by adding a very light dusting of white. The best way that I have found of doing this is by spraying paint from a toothbrush with the back of a knife. Practise first, however, because directing the spray can be tricky.

A number of interesting effects can be achieved by applying the paint with materials other than paint brushes – for example, tissue, silk, a sponge or a toothbrush. In figure 121 most of the colour was applied with a sponge. The paper was damped as if for a wash and the dark shapes were mapped in with light ink and a sponge, beginning with the trees in the

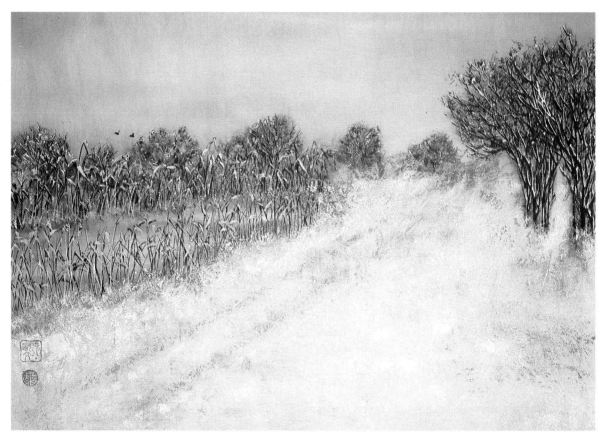

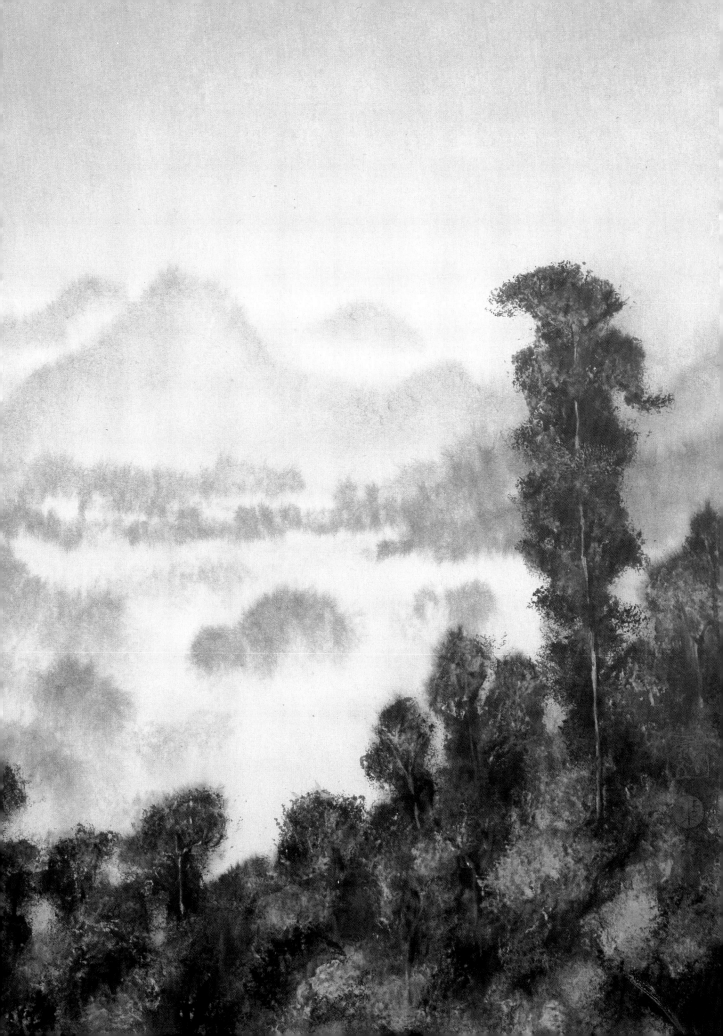

foreground. The mountains were painted in the normal way with a brush. Once the picture had dried, darker tones were added to the trees, followed by light green tones also applied with a sponge. The details of the trees were put in with a brush and a light wash added to the mountains and distant bushes. A wash was applied for the sky and mist.

The same technique was used for the picture of Ely cathedral in figure 122. The cathedral itself was drawn in with a small brush while the paper was still wet. A few details were added once the paper had dried. The sky was done using the tech-

*Figure 122* Ely Cathedral. *This painting is done with a combination of brush and sponge*

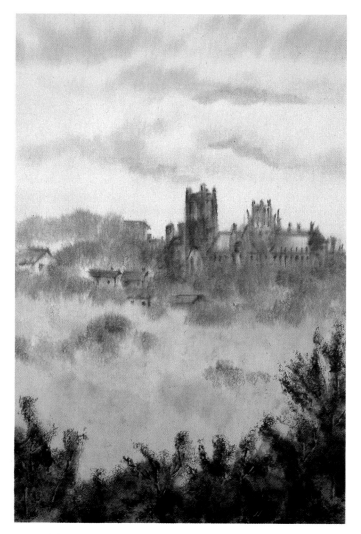

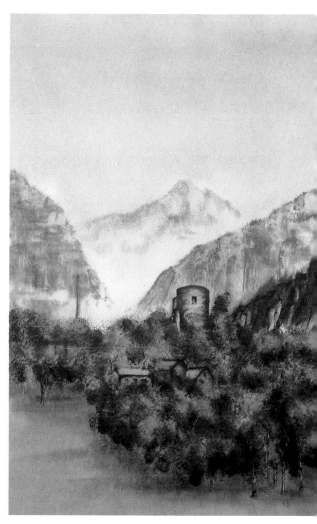

*Figure 123* Dolbadan Castle, North Wales. *Most of the techniques used in this picture are traditional, although the trees in the foreground are done with a sponge. The perspective is Western, but there is a very clear distinction between foreground, middle ground and distance*

niques described in the chapter on landscapes (see page 112). Most of figure 123, by contrast, was done in the style of a conventional Chinese landscape, although the trees in the foreground were applied using a sponge.

I have always been fascinated by skies and, living in East Anglia, it is impossible not to find them the most dramatic element in the landscape. Although by being fairly adventurous with colour quite spectacular results can be achieved with traditional

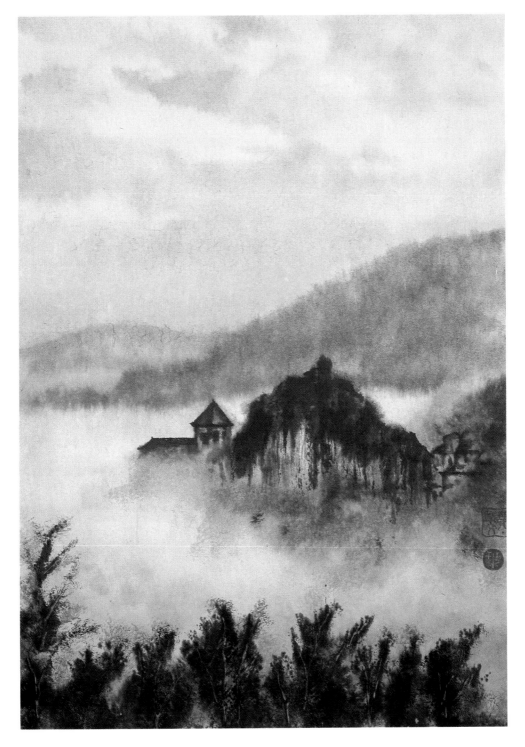

*Figure 124* St Cirque-la-Popie, Lot, France. *Again this illustrates a combination of traditional and experimental techniques. There is a clear foreground, middle ground and distance, and the clouds and distant hills are also done traditionally; but the trees in the foreground are done with a sponge and so are the mist effects, on damped paper*

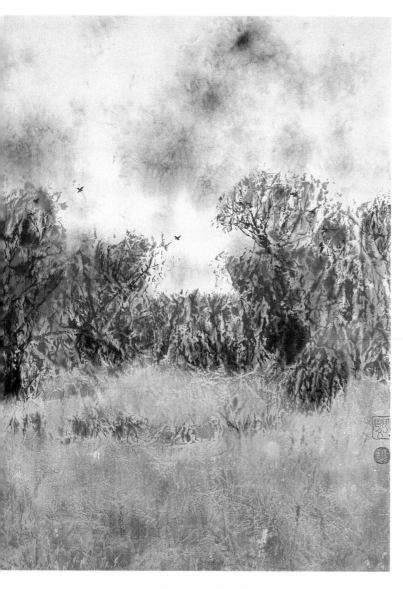

*Figure 125* Wandlebury, Cambridgeshire. *The unusual technique used to create the sky in this painting produces an interesting and effective result*

Chinese methodology (see figure 124), it is fun to experiment with different effects and methods. For example, figure 125 shows an interesting sky effect. To achieve this, wet the paper, screw it into a ball and place it in a shallow pool of very dilute wash colour. Remove the paper from the colour and turn the still-screwed-up ball upside down. Leave it for a few moments to allow some of the colour to seep down and then uncrum-

*Figure 126* The Mekong River. *The whole painting really consists of a wash* (private collection)

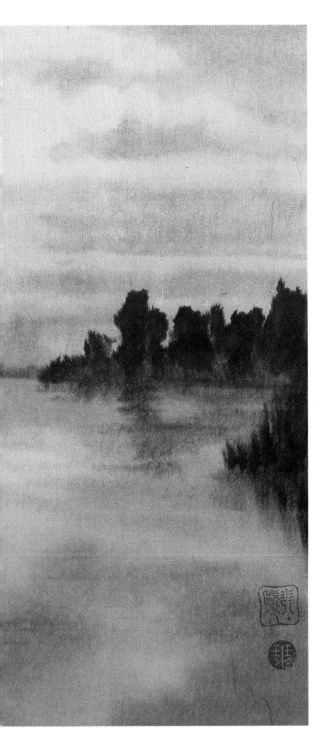

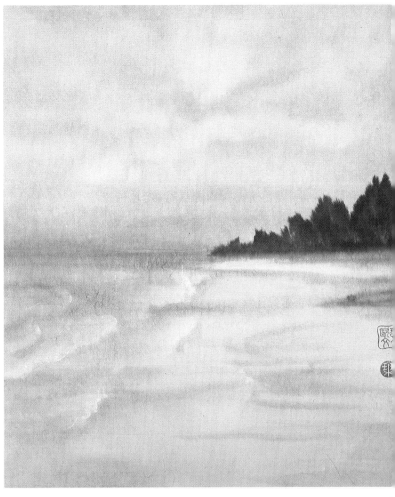

*Figure 127* Diani Beach, Kenya. *Untypically, white is added to the wash colour to help make the sky look threatening and to provide the waves running onto the beach*

---

ple the ball very carefully. The vegetation in the same picture was done by the crumpled paper technique used for figures 118, 119 and 120. A powdery yellow was added by means of the toothbrush technique to give the grass in the foreground a polleny look.

In figures 126–8 all the paint was applied with a very large soft brush. In figures 126 and 127 the whole painting was executed on wet paper. For the beach in figure 127 I applied a light colour wash and then added the streaks of darker tone (as for the waves described in the chapter on washes) which resulted in a wet-looking beach. I used white in the sky to make the clouds, mixing

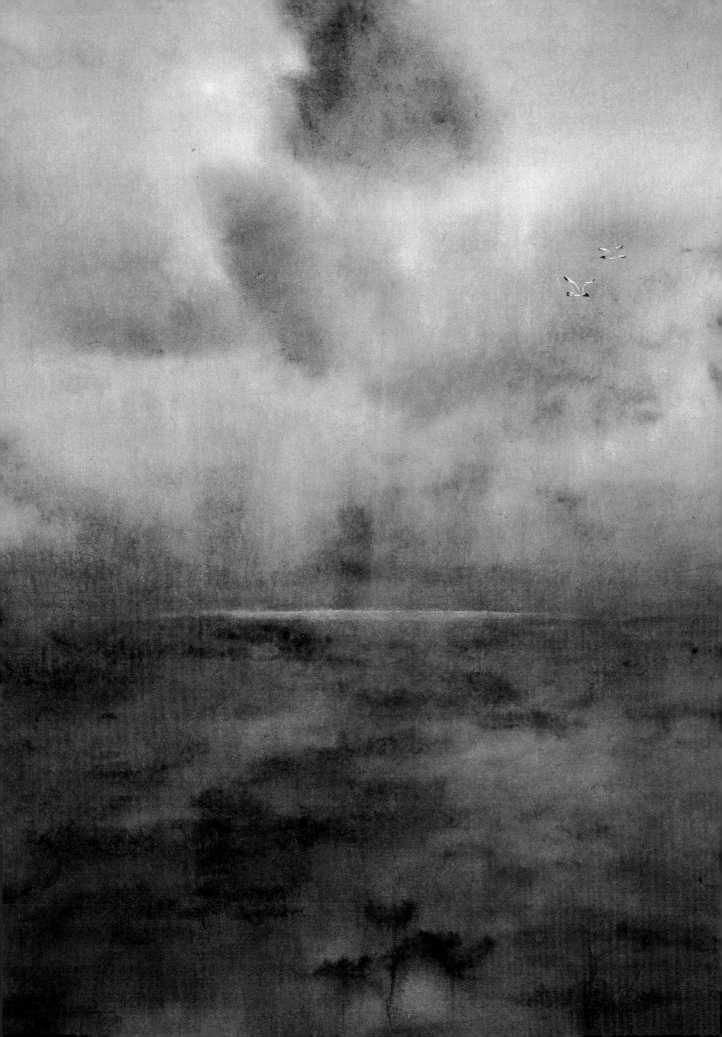

*Figure 128* Storm Brewing in the Channel.
*The whole picture is really a wash although*
*texture is added to the water with a dry brush*

this with ink for the darker sections to give
them substance. For the illustration of
Diani Beach on page 13, I began with dry
paper and outlined the boat and the man. I
then damped the paper and put in the sky
and the water, using wash techniques but
thickening some of the colours with white.
Lastly, after the paper had dried, I added
detail to the boat and figure.

Figure 128 was done in a similar way. In
this instance there was no focal point like
the shoreline in figure 126 or the trees in
figure 127, so the sky and sea were done
first. Some of the clouds were added very
wet and were not properly blended in, so
that they ran erratically into the previously
applied wash, creating a watery effect. Once
the basic blended wash had started to dry,
the sea was textured with a dry brush. The
light rays were added with carefully

directed strokes of a wash brush when the
painting was nearly dry. The birds were
added last of all.

The same technique used to suggest the
sun's rays, described above, can also be
used to create an effect of rain. Figure 129
shows how falling rain can be suggested by
raking the picture with strokes from a wide
wash brush. Rain and snow effects can also
be created by splashing dirty water or white
paint in small droplets as in the illustration
on page 17, although the lying snow here
was placed in spots where it would be likely
to collect. The wash was applied to the back
of the painting.

As you can see, you will usually find that
you need to employ a combination of
techniques to create the effect you desire.
For example, in figure 130 the vegetation in
the foreground was done by using the

*Figure 129* Rainy Scene in Norfolk. *The rain*
*effect is created with carefully directed strokes of a*
*wash brush*

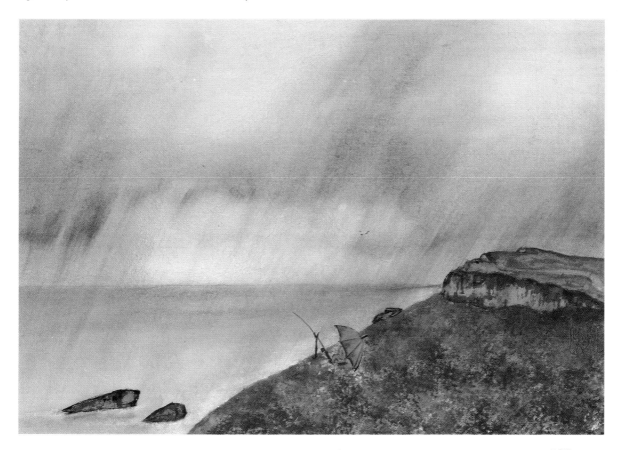

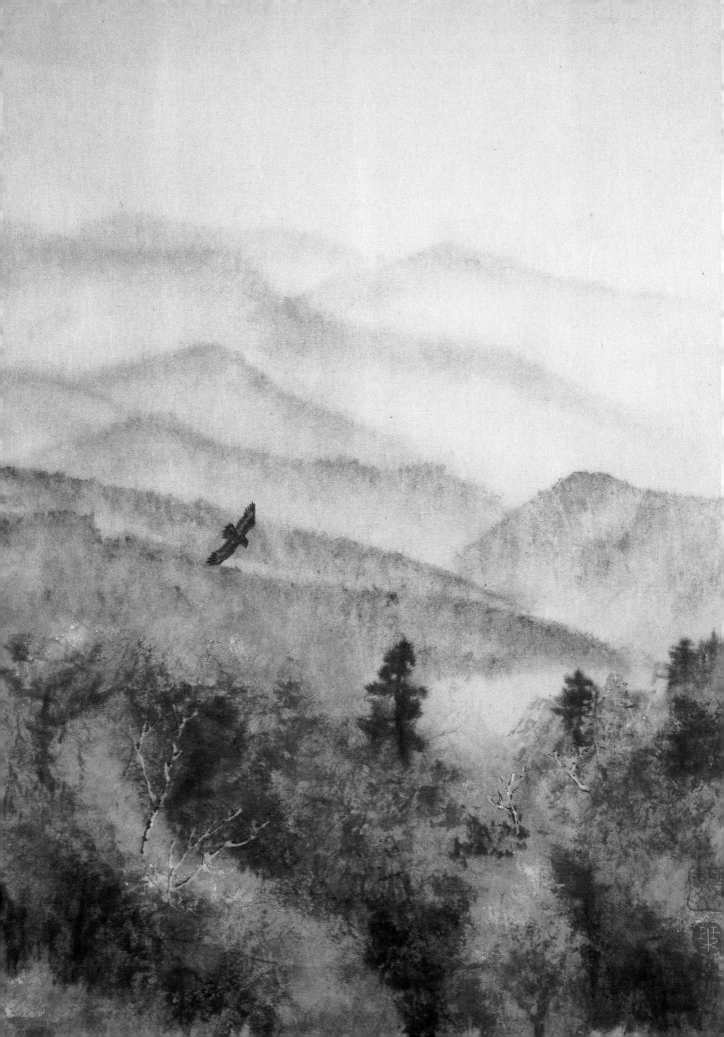

*Figure 130* The Smoky Mountains, USA. *A combination of different techniques using brush, sponge and crumpled paper is used in this painting* (private collection)

___

crumpled paper technique; the middle-distance hills were put in with a sponge to create a wooded effect; and the distant hills were painted with a brush on wet paper. In the illustration on page 136 the cliffs were painted by using the side of a dry brush; the vegetation was added with a sponge; and the water was applied with a wash.

If you want to experiment further, you can also make interesting pictures by using materials other than Chinese paper to paint on. Watercolour paper is non-absorbent and can create various effects, provided you remember not to try adding a wash. Silk is, of course, a traditional painting material; Chinese picture silk is sized with alum, but you can also work on non-sized silk. The fabric used for screen printing is another possibility. In fact, any fine woven fabric, even some synthetic ones, should take Chinese inks well.

# MOUNTING AND PRESENTATION

By the time you have finished a painting, especially if you have given it a wash or used the crumpled paper technique, it will probably be looking somewhat the worse for wear. You now need to back your painting in order to flatten and stretch it. Even if your paper is still in pristine condition the picture should be mounted to give it durability.

## Paper

Ideally you should use the paper specially made for backing pictures, but it is not available in the UK. However, you can find reasonable substitutes. Good-quality *shuan* paper is suitable as it tends to stretch at the same rate as the painting and therefore does not pull against it. Unfortunately it is rather expensive to use as backing and it leaves you with a somewhat flimsy end-product which tends to wrinkle when it is framed. If you do use it, remember that *shuan* paper is fragile when wet and be very careful as you smooth it onto the painting, otherwise you may end up with holes in your painting.

You can also back paintings with good-quality watercolour paper. This works well; the *shuan* paper takes to it fairly readily and the result is flat, even and robust. For very large paintings it is often the best solution since it can be bought in various sizes up to double elephant (117 × 142 cm/46 × 56 in). The disadvantages, though, are that it is very expensive and it can impart a slightly heavy effect to the painting.

The most satisfactory substitute for the proper thing that I have found is heavy-duty wallpaper or shelf-lining paper. It stretches in harmony with the *shuan* paper and absorbs the glue well. It is cheap and easy to find in builders' merchants and DIY shops. Its only real drawback is that it only comes in standard-width rolls and is therefore unusable for large paintings. You must only use 800 grade lining paper; the lighter-weight grades tend to wrinkle badly.

Cartridge paper, sugar paper, frieze paper and newsprint are all unsuitable for mounting Chinese brush paintings. Using them results in air bubbles and wrinkles.

## Glue

You can either use commercial wallpaper paste or make your own glue to the traditional recipe. If you opt for buying paste, make sure you get an old-fashioned wheat-based one. The best kind is paste for lightweight wallpapers. Avoid pastes that are based on synthetic compounds as they are too powerful and can cause your painting to disintegrate.

To make your own glue you should use ten measures of water to one of cornflour. Take nine of the water measures and boil them. Dissolve a very small crystal of alum in the boiling water. For every 2.25 litres (4 pints) of water you will need a piece of alum about the size of half a lump of sugar. Use the remaining measure of water to dissolve the cornflour and then add this to the boiling water, stirring continuously until the consistency is smooth and glutinous. Continue boiling until the glue is clear and relatively free of bubbles. Leave to cool.

You will also need a mounting brush (see page 23). These are readily available in a number of Chinese shops or, if you are feeling rich, you can use a Daler-Rowney 38 mm (1½ in) bristle brush. An ordinary household paint brush is usable at a pinch. The bristles must not be too stiff, however, and you should take extra care with it as it will be rougher on the *shuan* paper than a proper Chinese mounting brush.

## Mounting technique

You should work on an easily cleanable surface. A Formica table top is the most suitable working surface for mounting paintings.

Before you begin gluing your painting, cut a piece of backing paper that is at least 5 cm (2 in) larger all round than the painting. Place this within easy reach. Put your picture face down on the working surface and brush the glue all over the back until the whole painting is soaked. As you apply the glue, try to eliminate the air between the table top and your painting. This is easiest to do if you begin applying the glue in the centre and work outwards. If the paper becomes strained at any point you should work an adjoining area to ease it. Try to avoid creases, although any that do occur can usually be worked gently outwards. Do not hurry and above all do not get over-anxious; the glue will not dry even if it takes a while to work out air bubbles and creases. When the whole of your painting is soaked with glue and there is no air trapped between it and the table top, wipe up the glue that has spread onto the table and make sure that the area surrounding the picture is clean and dry. Place the centre of your backing paper onto the centre of your painting. Smooth the backing onto the picture by working outwards from the middle. When you are satisfied that the backing is properly stuck and there are no air bubbles, peel the paper carefully off the table and the picture will come with it.

You now need to ensure that your painting dries as flat as possible. If you want to do this in the traditional way you should place the picture face up and paste the area of backing paper round the edge of the painting. Then lift the backed painting carefully off the table, place it face first onto

a smooth, vertical wall and stick the margin down. Create an air cushion between the wall and the painting by pushing a small straw through and blowing some air in between the wall and the picture (figure 131). Once the painting has dried, peel it off the wall.

You may, however, not have a wall that you wish to cover with old glue stains and this much palaver is not really necessary if you are using the heavier weights of paper I recommended. It is a lot simpler to lie your painting face up on a clean, dry, flat surface and carefully weight the margin all the way round. Once the painting is dry, trim off the mount edges and you should easily get your picture to lie flat in a frame.

Problems with backing paintings are almost always caused by using the wrong equipment or materials. Make sure that you have the correct paper for backing; it must be soft, fibrous and fairly thick. Paper that

Figure 131 *The traditional method of drying a mounted painting*

is too thin or non-absorbent will wrinkle badly when it comes into contact with the glued painting. Your glue as well must be not only the right sort but also of the right consistency: if it is too watery it will not be sticky enough; if it is too thick it will not spread evenly and will tend to be lumpy. Follow the mixing instructions on the packet for the correct mixture. Glue that has been standing for several days may have gone thin so add some more paste.

Any other problems you encounter with mounting will probably be the result of

Prawns. *This painting is done in the style of Qi Baishi. Although framed in a conventional Western moulding, the simplicity of the Chinese-style composition is emphasized by the proportions of the mount. The painting is laid on top of a faintly figured Japanese paper and the deepest section of the surround is above the picture*

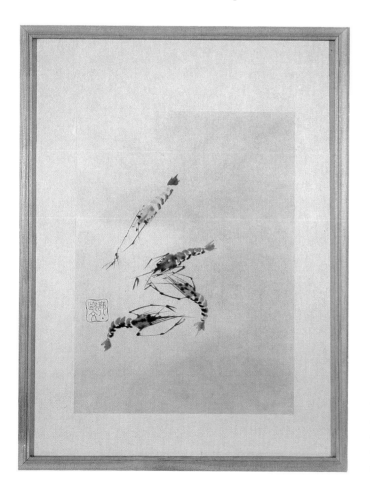

carelessness. As when applying a wash, you must not hurry the process. Because *shuan* paper is so fragile when it is wet, too heavy a hand may result in holes in your picture. Be patient if you have an air bubble or wrinkle that is more recalcitrant than usual; just work it gently out. Large or very long paintings need extra care because the *shuan* paper will not always stretch evenly. Sometimes it is better to settle for a small crease rather than risk a tear. Once you become skilled at mounting, you should be able to repair tears in the painting with patience and care.

## Presentation

Ideally, Chinese brush paintings should be mounted on a scroll with a silk surround. This is a very skilled process governed by a great many rules and much tradition. For example, monochrome paintings and those with delicate colour should have a light-coloured silk surround; dark-coloured silk should only be used for remounting Song and Yuan paintings; and elaborate paintings with lots of gold, blue and yellow in them should traditionally be mounted with a three-colour surround. There are even rules of taste governing the material for the end pieces of the scroll – most desirable are scroll ends made of black sandalwood.

Unfortunately there is nobody in the UK who can scroll paintings properly. Amateurish efforts to create scrolls always look just that – amateurish. Personally, I feel that if you cannot send your paintings to Hong Kong to be done properly then it is better to frame them.

Obviously how you frame your pictures is largely a matter of personal taste, but I have experimented over the years and it may be helpful for you to have some of my observations. I believe that Chinese brush paintings look best in simple frames with a light-coloured mount or surround. Framing shops are often eager to suggest mock bamboo mouldings but I always think that somewhat labours the point! Large landscape paintings seem to be able to take a Western-style matting surround cut in the usual way with the bottom slightly deeper than the top and sides, and placed on top of the painting. Very conventional landscapes and simpler subjects seem to benefit from a

compromise between the constraints imposed by a Western frame and the balance of a Chinese scroll. Traditionally the widest band of the silk surround is above the painting, the one beneath it being about two thirds as wide and the side bands narrow. The largest band is sometimes thought to represent heaven and the lower one earth; these two are occasionally referred to as the jade pools. If you do want to put a Chinese-style surround on your painting before you frame it you can now buy attractive Japanese papers in London (see page 138). When you use one of these as a surround, place the painting on top of it. Figure 132 shows the correct proportions for a Chinese scroll but you may find that you prefer to reduce the top and bottom measurements for paintings that are going to be framed.

The choice of glass for your frame is another matter for personal preference. You may find that non-reflecting glass helps to create the illusion that there is no glass there, but remember that it tends to have a dulling effect on colours.

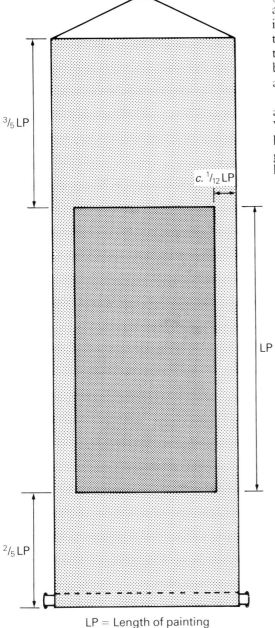

$^3/_5$ LP

c. $^1/_{12}$ LP

LP

$^2/_5$ LP

LP = Length of painting

*Figure 132 The correct proportions for a Chinese painting hung on a scroll*

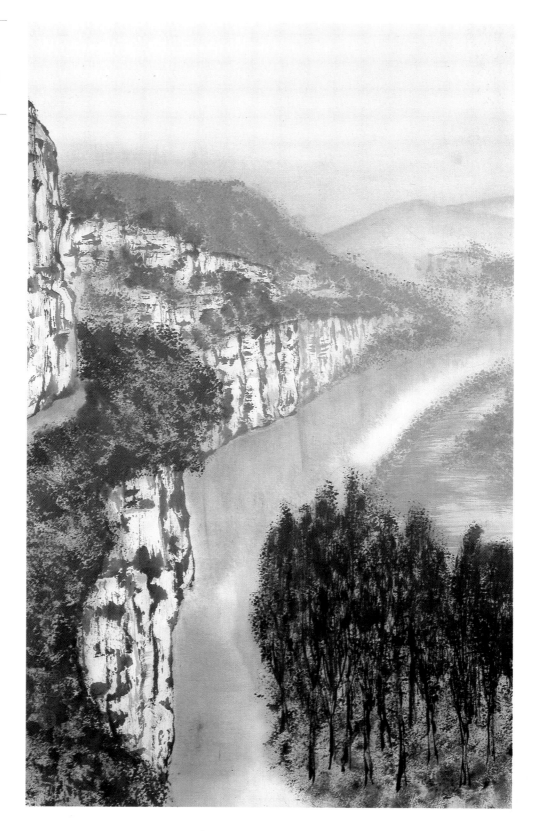

# IN CONCLUSION

By now you have probably decided what kind of Chinese brush painting you most enjoy doing and looking at. I do recommend that you try to see as many original paintings as possible, in addition to looking at reproductions in books. A number of museums throughout Britain have good collections of Chinese paintings and there are increasing numbers of exhibitions of modern works. Looking at actual paintings rather than their reproductions is helpful in that it will give you a better idea of scale. Chinese paintings are usually rather large and this can come as a surprise. Because you will be able to see the mount as well you will get a much clearer idea of proportions, since the way a painting is mounted is often very important to the overall impact it makes. Mounts are seldom included in reproductions of paintings in books. Also, of course, books often illustrate only a detail from a painting and not the whole thing. This is particularly regrettable in the case of Chinese paintings, where space is such an important element of the composition.

Even though it is important to have followed the whole course of lessons here in sequence, there is no reason why you should not now decide to concentrate on or specialize in one or two subjects that you particularly enjoy. You may want to paint nothing but birds and flowers, or perhaps traditional landscapes. You may choose to leave traditional styles alone and experiment with newer techniques. Whatever you decide, try to paint from your own experience and to develop an individual style while remembering the rules and precepts of Chinese painting.

You may even feel that creating finished paintings is not for you and that you prefer to use your skills decoratively. For example, many shops sell Chinese paper fans to which you can add your own designs. These are made out of Chinese paper that has been heavily sized and is therefore not absorbent. You might find coping with the folds a little awkward, but this can usually be overcome by holding the area to be painted flat with one hand while wielding the brush with the other. In the case of the Chinese fans that you see on sale or in museums, however, the paper was folded and the fan spokes added after the painting was done. You can buy fan bases and circular silk fan blanks in Hong Kong and China.

You can also use your brush techniques to apply designs to pottery. Use ceramic slips before firing for best results – this is not good for your brushes but produces effective designs. It is a good idea to keep a separate set of brushes for these craft uses, saving your good brushes for your serious paintings. Clothing, curtains, scarves, tablecloths, lampshades and wallpaper are all also suitable for Chinese designs, so you can see that there is an enormous range of opportunities to use your skills in Chinese brush painting to great effect.

The River Célé, Lot, France. *There is no need to feel that your paintings must use only traditional or only experimental techniques. By all means combine them as much as you like, as has been done in this painting*

# WHERE TO SHOP

## Materials and equipment

More and more art supply shops are selling materials for Chinese brush painting. Most good shops also have Japanese Teppachi colours and good-quality hake wash brushes. You should avoid, however, expensive kits containing brushes, ink stone and ink stick – the brushes are usually indifferent and you will pay heavily over the odds for the stone and stick. Listed below is a selection of specialist shops which stock an extensive range of Chinese painting materials.

Jub Tai Cheoon,
274 Queens Road C,
Hong Kong

Man Lune Choon,
29-35 Wing Kut Street,
Harvest Building,
2nd Floor, Flat B,
Hong Kong

Both of these shops specialize in art supplies and carry a very wide range of brushes, inks, colours, paper, silk, fan bases, chops, books and anything else you could possibly want. They will send items to the UK but it is a very slow process as you will need to write first for a catalogue and price list since goods have to be paid for in advance

Guanghwa Company,
9 Newport Place,
London WC2H 7JR
01-437 3737

This is the best-stocked shop in the UK. They have a selection of good brushes, papers, ink sticks and ink stones, and they also sell boxed tubes of colours. They can order chops for you and have a stock of pre-cut ones. They do mail order

Neal Street East,
3-5 Neal Street,
Covent Garden,
London WC2H 9PU
01-240 0135

A selection of good brushes, inks and ink stones. They also have paper

Collet's Chinese Bookshop,
40 Great Russell Street,
London WC1B 3PJ
01-580 7538

Brushes, inks, ink stones, colours and paper

Falkiner Fine Papers,
117 Long Acre,
London WC2E 9PA
01-240 2339

A wide selection of oriental papers both for painting on and for making Chinese-style mounts. They also sell some brushes and inks. You can buy a catalogue from them and they will process orders by post

| | |
|---|---|
| L. Cornelissen & Son,<br>22 Great Queen Street,<br>London WC2B 5BH<br>01-405 3304 | Brushes, inks and paper |
| Typhoon, Ltd,<br>64 Long Acre,<br>Covent Garden,<br>London WC2E 9JH<br>01-836 8566 | Brushes, inks, colours and paper |
| Philip Poole & Co.,<br>182 Drury Lane,<br>London WC2B 5QL<br>01-405 7097 | Brushes, inks and paper |
| Cheong Leen Supermarket,<br>4-10 Tower Street,<br>Cambridge Circus,<br>London WC2H 9NR<br>01-836 5378 | A number of Chinese supermarkets in the UK are increasingly stocking painting materials. You should be wary of the quality of the brushes but they often have good supplies of paper and colours |
| Mitsukiku,<br>4 Pembridge Road, London W11<br>01-221 5111<br><br>209 Kensington High Street, London W8<br>01-937 1440<br><br>26 North Audley, Street, London W1<br>01-491 1952<br><br>15 Old Brompton Road, London SW7<br>01-589 1725<br><br>157 Victoria Street, London SW1<br>01-828 0158<br><br>435 Strand, London WC2<br>01-240 3833<br><br>47 North Court, Birmingham Shopping Centre<br>021-643 7961<br><br>18 Brighton Square, The Lanes, Brighton<br>0273 29658<br><br>Royal Exchange Shopping Centre,<br>Market Street,<br>Manchester<br>061-832 5848 | Though these are primarily Japanese gift shops, most of them carry a modest range of papers and inks, and a few brushes |
| Samarkand Gifts,<br>31-5 Elm Hill,<br>Norwich NR3 1HG<br>0603 623344 | One of a number of oriental gift shops in the UK that stock Chinese painting equipment. This one has more than most and the quality is usually good |

139

| | |
|---|---|
| The Deben Gallery,<br>26 Market Hill,<br>Woodbridge,<br>Suffolk 1P12 4LU<br>03943 3216 | Paper, inks and ink stones, and some brushes. As an art supply shop they also carry the Japanese Teppachi colours that are not stocked by shops specializing in Chinese materials but which are carried by most good art shops |
| Centre of Restoration & Arts,<br>20 Folly Lane,<br>St Albans,<br>Herts AL3 5JT<br>0727 51555 | Brushes, paper, inks and colours |
| Chinese Art Centre,<br>50 High Street,<br>Oxford OX1 4AS<br>0865 242167 | Paper, inks, brushes and colours |
| The Brush & Compass,<br>14 Broad Street,<br>Oxford OX1 3AS<br>0865 246481 | Paper, inks and brushes |
| Chinese Arts Gallery,<br>Ambleside,<br>Cumbria LA22 0BZ<br>0966 33101 | Brushes, paper, inks and colours |
| Kam Cheung<br>28-30 Burleigh Street,<br>Cambridge CB1 1DG<br>0223 316429 | Paper, ink stones and sticks, colours, mounting brushes, some other brushes, and a few books on painting |
| Wagen Arts,<br>Hemel Hempstead,<br>Herts | Paper, inks, brushes and colours |
| Harberton Art Workshop,<br>27 High Street,<br>Totnes,<br>Devon TQ9 5NP<br>0803 862390 | Inks, paper, brushes |

## Materials and equipment: Australia

This listing of suppliers indicates only that the stores carry materials (brushes, ink stones, and paper) for Chinese brush painting. The quality and range of these materials cannot be guaranteed.

NEW SOUTH WALES

Oxford Art Supplies,
221 Oxford Street,
Darlinghurst, 2010
(02) 357 4601

Artist Supply Company,
83 George Street,
Sydney, 2000
(02) 27 4505

VICTORIA
Eckersley's,
55 Elizabeth Street,
Melbourne, 3000
(03) 62 5655

David Wang Emporium,
152 Bourke Street,
Melbourne, 3000
(03) 663 2111

WESTERN AUSTRALIA
Art Paper and Supplies,
243 Sterling Highway,
Claremont, 6010
(09) 383 1679

Jackson's Drawing Supplies,
148 William Street,
Perth, 6000
(09) 321 8707

SOUTH AUSTRALIA
Eckersley's,
21 Frome Street,
Adelaide, 5000
(08) 223 4155

QUEENSLAND
Art Requirements,
1 Dickson Street,
Wooloowin, 4030
(07) 57 2732

TASMANIA
Artery,
31 Davey Street,
Hobart, 7000
(002) 23 2130

AUSTRALIAN CAPITAL TERRITORY
Phillip Craft Supplies,
53 Cobee Court,
Phillip, 2606
(062) 82 2919

## Books on Chinese art

Most bookshops with a reasonable art department will have some books on oriental painting, but for those who want a larger selection the following specialist shops may prove helpful.

Han-Shan Tang, Ltd,
717 Fulham Road,
London SW6 5UL
01-731 2447

Luzac & Co.,
46 Great Russell Street,
London WC1B 3PE
01-636 1462

Guanghwa Company,
9 Newport Place,
London WC2H 7JR
01-437 3737

Collet's Chinese Bookshop,
40 Great Russell Street,
London WC1B 3PJ
01-580 7538

## Where to look at paintings

Many museums in the UK have oriental painting collections and the British Museum in London has an extensive one. Exhibitions of contemporary Chinese paintings are becoming increasingly common. Guanghwa Company quite often sponsors exhibitions and a permanent display of modern Chinese painting can be seen at The Far Eastern Art Gallery (Chi Mei Chai), 40 Great Russell Street, London WC2 (opposite the British Museum and above Collet's)

## Painting holidays

For the real enthusiast who is also well off, the Society for Anglo Chinese Understanding runs three-week holidays in China with tuition at an art school. The address for information is: SACU, 152 Camden High Street, London NW1 0NE 01-482 4292

# BIBLIOGRAPHY

I have not attempted to provide an exhaustive list of books about Chinese and Japanese painting here, including only those of which I have some personal knowledge. The first section contains details of books that I have found especially interesting or useful. In the second section I have listed a wider selection of works.

Au Ho-nien, *Ink and Colour Paintings of Au Ho-nien*, Art Book Co., Ltd, Taipei, 1984. A collection of works by one of the modern exponents of the Lingnam school.

Chen Shuren, *The Art of Chen Shuren*, Urban Council of Hong Kong, 1980. A biography of one of the founders of the Lingnam school, including examples of his works.

Gao Jianfu, *The Art of Gao Jianfu*, Urban Council of Hong Kong, 1981. A biography of the founding father of the Lingnam school, including examples of his works.

Gao Qifeng, *The Art of Gao Qifeng*, Urban Council of Hong Kong, 1981. A biography of one of the founders of the Lingnam school, including examples of his works.

Hua Junwu (ed.), *Contemporary Chinese Painting*, New World Press, Beijing, 1983. A selection of works by most of the important painters in China at present, together with essays about Chinese brush painting by leading Chinese authorities on the subject.

Kwo Da-Wei, *Chinese Brushwork – Its History, Aesthetics and Techniques*, Allanheld & Schram, Monclair, 1981, and George Prior, London, 1981. The sections on history and aesthetics provide a thorough discussion of the development and philosophy of Chinese brush painting and a clear explanation of the aesthetics.

Lim, Lucy (organizer), *Contemporary Chinese Painting – An Exhibition from the People's Republic of China*, The Chinese Culture Foundation of San Francisco, 1983. This exhibition catalogue contains examples of and interesting essays about contemporary Chinese painting by James Cahill, Michael Sullivan, Lucy Lim and other Chinese artists and critics.

Moss, Hugh, *Some Recent Developments in Twentieth Century Chinese Painting: A Personal View*, Umbrella, Hong Kong, 1982. Hugh Moss concentrates on the developments in Chinese painting that have taken place outside China.

Rodzinski, Witold, *The Walled Kingdom: A History of China from 2000 BC to the Present*, Fontana, London, 1984. A very readable history of China which puts the development of its art into the context of its general history.

Sullivan, Michael, *The Arts of China*, University of California Press, Berkeley, Los Angeles and London, 1967 (reprinted 1984). A history of Chinese art that puts painting in its wider context.

*Symbols of Eternity – The Art of Landscape Painting in China*, Clarendon Press, Oxford, 1979. A history of landscape painting and its philosophy.

Sze Mai-Mai (ed.), *The Mustard Seed Garden Manual of Painting*, Princeton University Press, Princeton, New Jersey, 1977, and Guildford, Surrey, 1977. The easiest to come by of the classic Chinese texts on painting methods.

Wong, Frederick, *Oriental Watercolor Techniques*, Watson-Guptill, New York, 1977, and Pitman Publishing, London, 1977. Although Frederick Wong is not strictly a Chinese

brush painter, he provides a lot of ideas for interesting ways of using Chinese paper, ink and colours.

Addis, Stephen, *Nanga Paintings*, Robert G. Sawers, London, 1975

Awakawa, Yasuichi, *Zen Painting*, translated by John Bester, Kodansha International, Ltd, Tokyo, New York and San Francisco, 1970

Bancroft, Anne, *Zen – Direct Pointing to Reality*, Thames & Hudson, London, 1979

Barnet, Sylvan & Burto, William, *Zen Ink Paintings*, Robert G. Sawers, London, with the co-operation of Kodansha International, Ltd, 1982

Binyon, Laurence, *Painting in the Far East – An Introduction to the History of Pictorial Art in Asia, Especially in China and Japan*, Dover Publications, Inc., New York, 1969

Cahill, James, *Chinese Painting*, Skira, Geneva, 1977, and Macmillan London, Ltd, London and Basingstoke, 1977

Capon, Edmund, *Chinese Painting*, Phaidon Press, Ltd, Oxford, 1979

Clayre, Alasdair, *The Heart of the Dragon*, Collins/Harvill, London, 1984

Fang Zhaoling, *Painting and Calligraphy*, Fang Zhaoling, Hong Kong, 1981

Frunzetti, Ion, *Classical Chinese Painting* (original title: *The Spirit of Chinese Painting*), Abbey Library, London, 1976

Hay, John, *Masterpieces of Chinese Art*, Phaidon Press Ltd, London, 1984

Hejzlar, Josef, *Chinese Watercolours*, Cathay Books, London, 1978

Hillier, J. R., *Japanese Drawings – from the 17th through the 19th Century – Drawings of the Masters*, Little, Brown & Company, Boston and Toronto, 1965

Hirayama, Hakuho, *Sumi-e Just For You – Traditional 'One Brush' Ink Painting*, Kodansha International, Ltd, Tokyo, New York and San Francisco, 1979

Ho Huai-Shuo, *Inner Realms of Ho Huai-Shuo*, Hibiya Co., Ltd, Hong Kong, 1981

Hong Kong Museum of Art, *Early Masters of the Lingnan School*, Urban Council of Hong Kong, 1983

Hulton, Paul & Smith, Lawrence, *Flowers in Art from East and West*, British Museum Publications, Ltd, London, 1979

Jenyns, Soame, *A Background to Chinese Painting*, Sidgwick & Jackson, London, 1935, reprinted by Schocken Books, New York, 1966

Lai, T. C., *Chinese Seals*, Kelly & Walsh, Ltd, Hong Kong, 1976
*Noble Fragrance – Chinese Flowers & Trees*, Swindon Book Company, Kowloon, Hong Kong, 1977

Lao Tsu, *Tao Te Ching*, translated by Gia-Fu Feng & Jane English, Wildwood House, Ltd, London, 1973

Li Chu-tsing, *Trends in Modern Chinese Painting*, Artibus Asiae Publishers, Ascona, Switzerland, 1979

Lin Yutang, *Imperial Chinese Art*, Omega Books, Ware, Hertfordshire, 1961

March, Benjamin, *Some Technical Terms of Chinese Painting*, Paragon Book Reprint Corporation, New York, 1969

Rawson, Philip & Legeza, Laszlo, *Tao – The Chinese Philosophy of Time and Change*, Thames & Hudson, London, 1973

Sickman, Laurence & Soper, Alexander, *The Art and Architecture of China*, The Pelican History of Art, Penguin Books, London, 1956 (reprinted 1978)

Siudzinski, Paul, *Sumi-e: A Meditation in Ink – An Introduction to Japanese Brush Painting*, Sterling Publishing Co., Inc., New York, 1979

Stern, Harold P., *Birds, Beasts, Blossoms, and Bugs – The Nature of Japan*, Harry N. Abrams, Inc., New York, 1976

Sullivan, Michael, *The Meeting of Eastern and Western Art – From the Sixteenth Century to the Present Day*, Thames & Hudson, London, 1973
*Chinese Landscape Painting – in the Sui and T'ang Dynasties*, University of California Press, Berkeley, Los Angeles and London, 1980

Tregear, Mary, *Chinese Art*, Thames & Hudson, London, 1980

Vedlich, Joseph, *The Prints of the Ten Bamboo Studio*, Crescent Books, Crown Publishers, Inc., New York, 1979

Wang, C. C., *Mountains of the Mind - The Landscapes of C. C. Wang*, Arthur M. Sackler Foundation, Washington DC, 1977

Watson, Professor William (ed.), *The Great Japan Exhibition - Art of the Edo Period 1600-1868*, Royal Academy of Arts catalogue, in association with Weidenfeld & Nicolson, London, 1981-2

Weng Wan-go, *Chinese Painting and Calligraphy*, Dover Publications, Inc., New York, 1978

Whitfield, Roderick, *Five Modern Masters: Chinese Traditional Painting 1886-1966*, Royal Academy of Arts catalogue, London, 1982

Williams, C.A.S., *Outlines of Chinese Symbolism and Art Motives*, Dover Publications, Inc., New York, 1976

Wong Kuan S. & Adams, Celeste, *In the Way of the Master - Chinese and Japanese Painting and Calligraphy*, a bulletin of the Museum of Fine Arts, Houston, Texas, NS Volume VII, Number 3, February 1981

Wong Shiu Hon, *Kao Chien-fu's Theory of Painting*, University of Hong Kong, 1972

Wu, Victor (compiler), *Contemporary Chinese Painters 1*, Hai Feng Publishing Co., Hong Kong, 1982

Zhaolina Publishing House, *A Selection of Contemporary Chinese Paintings - From the Collection of Song Wenzhi*, Beijing, 1981